Growing Up
JACKSONVILLE

To Jim, Thanks so much for your support! Hope you enjoy this trip down Memory Lane! Dottie

Growing Up
JACKSONVILLE

A '50s & '60s
River City Childhood

Dorothy K. Fletcher 2012

Dorothy K. Fletcher

Charleston · London

THE
History
PRESS

Published by The History Press
Charleston, SC 29403
www.historypress.net

Copyright © 2012 by Dorothy Fletcher
All rights reserved

First published 2012

Manufactured in the United States

ISBN 978.1.60949.518.3

Library of Congress Cataloging-in-Publication Data
Fletcher, Dorothy K.
Growing up Jacksonville : a '50s and '60s River City childhood / Dorothy Fletcher.
p. cm.
Includes bibliographical references.
ISBN 978-1-60949-518-3
1. Jacksonville (Fla.)--Social life and customs--20th century--Anecdotes. 2. Jacksonville
(Fla.)--Biography--Anecdotes. 3. Children--Florida--Jacksonville--Social life and customs--
20th century--Anecdotes. I. Title.
F319.J1F54 2012
975.9'12--dc23
2012006918

Notice: The information in this book is true and complete to the best of our knowledge. It is
offered without guarantee on the part of the author or The History Press. The author and
The History Press disclaim all liability in connection with the use of this book.

All rights reserved. No part of this book may be reproduced or transmitted in any form
whatsoever without prior written permission from the publisher except in the case of brief
quotations embodied in critical articles and reviews.

Contents

CONTENTS

Introduction

One of the saddest images in my memory is that of my family's old black rotary telephone sitting on the floor of our house in East St. Louis, Illinois. The movers had taken the table it used to sit upon, and it was the only thing left in the house we were leaving. As my parents searched one last time for any forgotten items, I stood on the verge of tears in the vast empty space of what had been our living room. The old phone was sure to miss us, I kept thinking, but I knew I was the one who would be doing the missing.

This old house we were abandoning had been my grandparents' before they moved to Texas. My parents bought it from them, and instantly, it became our house. And now we were leaving it—the only place I had ever known as home.

The year was 1957, and my father had been transferred to Jacksonville. Initially, I was elated, believing Florida to be the Promised Land, but our arrival changed my opinion. We didn't have oranges growing on trees of the bare sandy lot of our tiny Westside rental, as I had been led to believe. The beach was at least an hour's drive away, and we nearly froze to death that first winter in the Sunshine State, the only warmth in the house coming from a little space heater.

Right after I passed Miss Milling's second grade at Hyde Park Elementary, things began to look up. My parents bought a new house on the Southside on the outskirts of Jacksonville. Our new house was bigger and had a big yard where we could plant an orange tree. It had a furnace for the winter and fans to cool us in the summer, and there were many kids in the neighboring houses. A new school was opening just around the corner. It was so new that it didn't have a name. It simply had a number, 203. I would be in Mrs. Palmer's third-grade class in the fall of 1958, and within the year, we would name our school South San Jose. I began to settle in, and I have been in the same neighborhood ever since—some fifty-three years.

The impact of the lonely telephone image was most profound. Sometimes it comes back to me in dreams whenever I am fearful of change or abandonment. I have concluded that because of my early and somewhat traumatic "uprooting," I needed to put down deep roots wherever I landed.

So, once we survived the first winter in 1957–58, I let the magic of Jacksonville happen, and I embraced the place. I fell in love with bike rides through golden mornings as my new friends and I sped down Old Kings Road to our games. I built forts with the guys in dewy fields or ran the bases with the gang in kickball games in vacant lots. School brought more friends, learning experiences, Brownies and church activities. Before I knew it, I was going to sock hops and Friday night football games. And all this happened while the adults in our lives pestered and protected us.

Growing up Jacksonville may not have always been easy, but those of us who grew up here flourished in a beautiful setting with many vigilant and concerned people making sure we were safe. My hope is that this book will be a celebration of those people, places and things that helped us become who we are, as a people and a city.

A Belated Thank-You

I have always had a deep and abiding affection for the U.S. Navy, having lived in Jacksonville most of my life. Maybe it's because my father was a sailor during the Second World War and during the Korean conflict. Maybe it's because in 1962, when I was in the seventh grade, I fell in love with a cute starting quarterback for Navy, Roger Staubach. But mostly, it's because the Naval Air Station (NAS) of Jacksonville has been an intriguing hive of masculine activity humming busily away across the St. Johns River from most of the houses in which I have ever lived.

For years, I have monitored the P-3 Orions as they float laboriously in and out of NAS on the prevailing winds. As a matter of fact, the window of my childhood bedroom lay directly under the summer flight pattern, and I was often awakened by landing lights shining down on me through bedroom curtains. I could have been terrified, but instead, I was comforted by these massive, groaning aircraft that were there to protect me, my family and our freedom.

There is, however, an event that had a profound impact on my affection for the navy and its members. One beautiful weekend morning, my little sister, Betsy, went out to get the newspaper from the driveway. As she tells the story, she was barefoot and still in her nightgown when two very loud

jets flew directly over her head. They disappeared over a bank of trees, and then she heard a horrible crash. The explosion created a small mushroom cloud in the sky over the trees, and Betsy ran into the house screaming.

My family and the rest of the neighborhood had already been awakened by the concussion of the crash, which had violently rattled the windows and doors. Soon, everyone was in his or her front yard as the sounds of sirens began to fill the morning air.

My father and our next-door neighbor, Mr. Jordan, took the family Ford in the direction of the crash to learn what had happened and to see if they could help. When they returned, they confirmed Betsy's eyewitness account—one of the planes she had seen had indeed crashed in the Meadowbrook Farm pasture just beyond the edge of our neighborhood. The pilot had not survived.

Oddly enough, what I know of the event comes totally from second-hand information. I had been spending the night at a friend's house in another neighborhood when all this excitement occurred. As I listened carefully to the many spirited conversations traveling among the families on our street, I began to piece together a powerful story that became as much a real memory to me as if I had been there to witness it.

Most neighbors agreed that the plane had come from NAS, and some conjectured that the pilot had been careless and miscalculated his assent during takeoff. Some thought his craft had suffered a malfunction that prevented his ejecting from the craft. Some said he was just one unlucky soul, but others were certain that he had sacrificed his life to keep his disabled jet from crashing into our houses.

Whatever actually happened, we will never know for certain; but there exists a real possibility that his aircraft could have taken out a row of homes and killed any number of civilians as they slept in on a Saturday or Sunday morning if he had ejected. My house and family were directly in his path.

Now, almost fifty years later, I am most grateful that my destiny did not take a dreadful turn on that morning. My family and my neighbors were spared, and I have always felt tremendous gratitude toward the pilot who decided not to eject. I still believe that he stayed with his jet and rode it into a field so he wouldn't hurt anybody.

All this was on my mind as Memorial Day 2011 approached. I wanted to pay tribute to the pilot in "By the Wayside," the column I was still writing for the *Florida Times-Union* at that time. I never got to write the piece.

In preparing my column, I contacted as many people from the old neighborhood as I could find. Even though everyone I talked to remembered the crash and many of the minute details of it, no one could tell me with any accuracy when it occurred. Some said 1969, some said 1961 and some picked years in between.

All that my sister remembered was that she was young and terrified. At first, she thought she had witnessed "the bomb." All that my brother Scott remembered was that because he was still a little kid, my father would not take him to the scene of the crash.

None of these pieces of information was helpful in locating the microfilmed newspaper article containing the actual facts of the event. I searched and discovered a fascinating book, *Naval Air Station Jacksonville, Florida, 1940–2000: An Illustrated History* by Ronald M. Williamson. After spending several hours reading its detailed chronologies, I could find no mention of a crash with details that matched those of family and neighbors. I then went to the NTBS (National Target Base System) with lists of all plane crashes. Nothing. So I abandoned the story idea and moved to another topic as my deadline grew near.

When I began to collect stories for *Growing Up Jacksonville*, I decided that I would make one last, concerted effort to find this pilot's name and the particulars of his passing. I spent many more hours interviewing and re-interviewing friends and friends of friends. Then, I spent many hours at the downtown Jacksonville Public Library rolling through microfilm to the point that my vision was blurred and my eyes ached.

Finally, when I was just about to abandon the project for the second time, I found the article for which I was looking. The *Florida Times-Union* had run a story about the crash on the front page of the Monday, April 27, 1964 newspaper. The headline read "Southside Jet Crash Kills Pilot." The article said, "An F1-Fury jet fighter crashed and exploded in a Southside cow pasture yesterday morning; killing its Naval reserve pilot and jarring scores of homes within a quarter-mile area."

According to the article by Dick Crouch, the jet crashed in a pasture owned by Meadowbrook Farms, between Old St. Augustine Road and the tracks of the Florida East Coast Railroad. The pilot was on a cross-country training flight, and he had just taken off from NAS after refueling. The jet that crashed was the leader of two F1-Furies, and it disintegrated and exploded upon impact, leaving a five-foot deep crater in the ground.

The NAS safety officer, Lieutenant Commander H.A. Lague, told Crouch that the jet was apparently banking when it hit. "A wing tip plowed a deep furrow into the crater made by the explosion." The article also mentioned that the jet "had disintegrated into thousands of pieces some of which were tossed 1,600 feet. A chunk of metal severed a pine tree in the pasture."

The most poignant piece of information came at the end and agreed with what many of my neighbors and I had suspected. A navy spokesman said that the pilot "may have chosen to ride the plane out of the congested area instead of ejecting."

Lieutenant Grant R. Williams was the man who made this choice. He was only thirty-three years old and the father of four, and his sacrifice has not been forgotten by my family or by me. If he had made a different choice, it is very possible that my sister and family would have been in the midst of a crash site and possibly been hurt or killed. I find it almost unimaginable to consider how such a tragedy would have impacted my life.

I wanted to thank this pilot for his service and for the lives of my family members and friends. I am glad that I was able to find his story so that the memory of his sacrifice will not be lost in the not-always-accurate recollections of human beings. Neither will it be lost in the musty corners of library microfilm files.

I wish, therefore, to dedicate my book to Lieutenant Grant Russell Williams of Webster Grove, Missouri, and to the U.S. Navy for producing such men of courage and honor.

The Joys of
Skateland Roller Rink

An Unintended Time Capsule

It was easy to imagine it as I stood on the old wooden floor of PRI Production Company at 1819 Kings Avenue, where I had gone to do research on a story. The huge building had once been a roller-skating rink built in 1950, the year in which I was born. I could imagine the swirling couples, the daredevil boys racing and the little kids moving in tentative shuffle-like motions across the slick, hardwood floor. The air would have been filled with the sounds of organ music and, later, with the more modern sounds of disk jockeys playing rock-and-roll records.

I had already done some preliminary background work. In an advertisement in the Yellow Pages of the *1960 Southern Bell Telephone Directory for Jacksonville, Florida*, Skateland was touted as "One of the South's Largest" skating rinks. It was open nightly from 7:30 to 10:30 p.m. and had special matinees on Saturday and Sunday. It was "Air Cooled," and "Professional Instruction" was available. The telephone number was EX 8-3601.

I had also interviewed some people who knew how much fun it was to go to Skateland. First, I had spoken with Betty Stafford, sixty-one, a retired employee of BellSouth. She told me all about this wonderful place where countless Jacksonville youth from the '50s to the '70s enjoyed many hours of their leisure time.

"I loved Skateland!" she said. "I used to wear this lavender and white gingham skating dress, made by the mother of my friend Joyce Ann, and I flew across the wooden floor in my skates with no helmet or wrist guards, and I never got hurt. Oh, and I loved the Hokey Pokey too."

Another person with whom I had spoken was Stafford's brother, Tony Allen, sixty-three and an employee of CSX for forty-one years. He was a disc jockey at Skateland in 1967. Radio station WPDQ ran ads for Skateland, but its on-air personalities didn't want to work as deejays there. So Allen stepped up.

"I worked on Friday and Saturday nights from seven to midnight for twenty-five dollars a night," Allen said. "It was great money for a kid back then. There would be about one hundred kids each night skating and having a good time, and we had hired some navy guys to work as floor marshals—guys who would blow a whistle if you got too fast or rowdy."

Another person I got in touch with was Marie Tiffany Howell, sixty-one, a retired preschool teacher. She was amazed at the memories that flooded back to her when I asked her to think back on Skateland. "It was a safe place for us to go and have fun," she said, "active fun where you actually move around. My sister Anita and I went there every Saturday from three to five, and, as I recall, the place was owned by the Caraway family. Mr. Caraway, a sweet man, was always there, and Tink and Shirley Weaver gave skating lessons. It was so much fun!"

Howell provided me with a thirty-five-cent program of an event that took place at Skateland from July 14 to July 17, 1959. It was the 1959 RSROA (Roller Skating Rink Operators Association) Amateur Roller Skating Championships/Southern Region. On the cover of this thirty-page program is a picture of Tink and Shirley Weaver, the instructors Howell mentioned.

Inside the program is a welcoming letter from the mayor of Jacksonville, Haydon Burns. It reads:

> *Greetings,*
> *It is my pleasure to extend to all of you who are participating in the Southern Regional Roller Skating Championship Tournament June 14–18 a most cordial welcome to Jacksonville.*

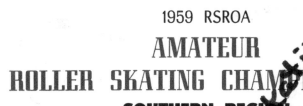

1959 RSROA

AMATEUR
ROLLER SKATING CHAMPIONSHIPS

SOUTHERN REGION

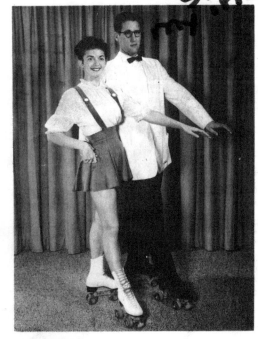

SKATELAND
1819 KINGS AVE.
Jacksonville, Fla.

35¢

JUNE
14·15·16·17

The program for the 1959 RSROA Amateur Roller Skating Championships/Southern Region. *Courtesy of Marie Tiffany Howell.*

You will find our city a most hospitable community and I am confident you will enjoy your visit here. We are delighted that Jacksonville has been selected as the host city for this Championship Tournament, and it is our

hope that this will prove to be one of the most successful and pleasant tournaments ever held.

Sincerely Yours,

Haydon Burns
MAYOR-COMMISSIONER

There is also a letter from Mr. G.V. Caraway, the owner of Skateland. It reads:

Welcome to Skateland!
It is indeed a great privilege to extend a warm, sincere welcome to all the Operators, Professionals, Contestants, Officials, Parents and guests to the 1959 Southern Regional Amateur Roller Skating Championships. We sincerely hope that everyone attending this year's Southern Regional will enjoy their stay with us at Skateland.

We hope that this year's event and affairs will linger long in the memories of those attending and participating, and may your visit in Jacksonville be most pleasant and that your convention will be successful.

Sincerely,
G.V. Caraway, Manager
Skateland Roller Rink

It is also fascinating to see all the ads from companies that no longer exist. There are ads for Sabel Bros. Leather Co. at 130 East Bay Street, Abe Liverts Records in the Town and Country Shopping Center and the Texas Drive-In Restaurant at 1321 San Marco Boulevard with its "Curb and Dining Room Service."

There are also many ads specifically focused on the skating population. These ads were provided by Jack Adams & Sons, Inc., which featured "Bonny's Hug Me Tights & Skating Skirts," by Union Hardware Toe-Stops from Torrington, Connecticut, and by Cottrell Silenced Non-slip Skate Wheels, which were "Like Skating on a Cloud."

Then there are ads that simply supported the skaters. One is "Compliments of Marvin's Service Station and Garage on 7735 Atlantic Boulevard." There is one that was "Compliments of Cinotti's

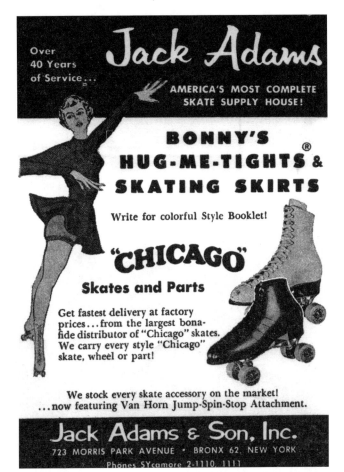

An advertisement from the Amateur Roller Skating Championships program. *Courtesy of Marie Tiffany Howell.*

Baking Company, 7206 Beach Boulevard," and one that simply reads "Compliments of a Friend."

Howell also provided me with a newspaper clipping from an unidentified newspaper (probably either the *Jacksonville Journal* or the *Florida Times-Union*). The story has no byline, and the date of the paper was removed when it was cut out, but the article is definitely about the 1959 Amateur Roller Skating Championship. The news article reads:

> *INTERMEDIATE CHAMPS*
> *George Davis and Carol Kotula of Hollywood Fla., captured first place in the Intermediate Pairs at the Southern Regional Roller Skating*

Championship, now underway at Skateland rink. Jacksonville's Kenneth Thrift and Donna Miller won second place with Billy Mashburn and Camille McKensie, also of Jacksonville taking third. The skating championship will end tonight.

One person with whom I talked is actually mentioned in this newspaper article: Ellen Ruffner Pierce, now sixty-one. She is listed at the end of the newspaper article as one of three contestants to perform in the juvenile pairs on the second night of the championship. Her partner was David

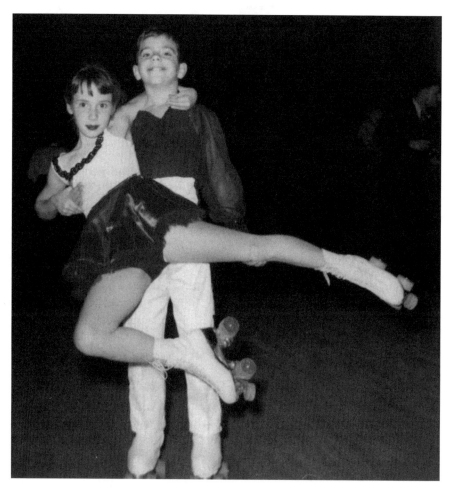

Ellen Ruffner and David Weaver skating at Skateland. *Courtesy of Ellen Ruffner Pierce.*

Weaver, the son of instructors Tink and Shirley Weaver, and she has several metals to prove her award-winning skater status.

As far back as Pierce's days at San Jose Elementary School, she was into skating. Almost every day after school, Shirley Weaver would pick her up and take her to Skateland for her lessons and for her to watch other skaters. Pierce said, "I know the reason I love liverwurst sandwiches now is because Shirley Weaver used to serve them to me after school and before my lessons. The Weavers were so nice. Shirley was a bit strict and prissy, and Tink was just plain funny."

Pierce went on to recount several interesting things that she did while at Skateland: "One thing I really liked to do was square dancing on skates. It was really hard, but I really enjoyed it. And I also remember that there was a way in which we got to choose partners. Skaters were given paper bags, and when you found the person you wanted to skate with, you'd blow up the bag and pop it. Such fun!"

Pierce also recounted how Interstate 95 was just being built behind the Skateland structure, and she and her friends often went outside to check out the progress of the construction, something they were never supposed to do when wearing their skates. "I can remember that Shirley was not pleased with us at all. It ruined the surface of our skate wheels to be on any surface other than the wooden floor of the rink."

For Pierce, Skateland was a lot more than just a place to take lessons and to hang out. It was part of her life in a different way. "My father, Herbert Ruffner, was the organist at Skateland for many years. He would work all day at Prudential and then go play at Skateland from 7:30 to 10:30 [p.m.]. He also played on Saturdays at the Crystal Lounge in Lakewood and at the Town House on Sundays. My mother was a pianist, and she played piano at Buddy Sherwood's Dancing Studio."

Pierce said that years later, her father played organ at the Center Theater, when she herself worked behind the candy counter. He went on to play at the Florida Theater, the Empress Theater and the Imperial Theater.

"When Dad was performing at Skateland, though, I wasn't allowed to go up in the loft where he played. I can't remember if it was because of safety reasons or that they just didn't want me disturbing my father. I still was very proud of him."

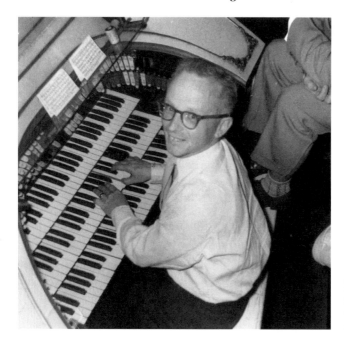

Herbert Ruffner, the organist at Skateland. *Courtesy of Ellen Ruffner Pierce.*

Finally, one last person I interviewed remembers Skateland for other reasons. Longtime Jacksonville resident Kathy Owens, who is sixty-one and a hairdresser at Hot Looks Salon, said:

When I was in junior high, my mother felt Skateland wasn't a good place for me to go to. It was okay for the older kids, but she thought there was a bad element there—sailors, mostly. When the ships came in, the sailors went skating with their tattoos and such, and she felt it best to keep her young girls away from those grown men. I really wanted to go, but my mother never would let me.

Bobby, my husband, remembers Skateland because of an unusual incident. His mother made his five-year-old sister a skating outfit with a small top and skating skirt. Her stomach was exposed a little, but she was only five, so her mother thought it would be okay. Well, they wouldn't let them in because of it. Someone checked you out at the door, apparently, and they had decided she was indecent. The mother had to call the father, and he was mad because he had to go back and get them.

Thumbing through the pages of the program, reading the clipping and talking to people who remembered Skateland, I could feel myself fall back to a simpler time in my life. I remembered when I would go to Skateland with my church group on Sunday afternoons and clumsily make my way around the rink. I also recalled the times when some of us Girl Scouts went to Skateland to earn skating badges. And I'll never forget the Saturday afternoon dates with boyfriends whose parents had to drive us to the rink because we didn't have driver's licenses yet. Just remembering these things let me feel like a kid again, and I had the uncanny need to lace up my high-top skates so I could again move across the floor with the greatest of ease.

However, I needed to continue my research by interviewing Randy Goodwin, the forty-six-year-old president and owner of **PRI Productions**, which is now housed in the old Skateland building. He began working there in 1981 when the place was Brandon's Camera Store, and he has treated the building with tremendous reverence, since it has been part of his life for so long.

As we talked, Goodwin showed me all around the PRI Production complex. First, he showed me the loft where Herbert Ruffner played the organ to provide skaters with music. Then, he showed me where the concession stand, now a kitchen, once was. He even showed me the birthday room, a place for private birthday parties. The best part, though, came when he ushered me into his office and showed me a large table with a huge pile of junk on it. Upon closer examination, I realized that it was an amazing collection of memorabilia from a distant time—my youth.

"When we were renovating, we removed a wall in the men's restroom," Goodwin said. "That's when we discovered this 'time capsule' of stuff hidden behind the wall. As near as we can figure, these wallets had been stolen from lockers. When the money was removed, the thief threw these things down a hole at the top of the wall."

He went on to tell me that sometime in the late '50s and early '60s, while unsuspecting skaters were out on the wooden rink gracefully moving to the organ music, a sinister force was lurking in the shadows. An employee or unscrupulous patron was stealing items from the lockers

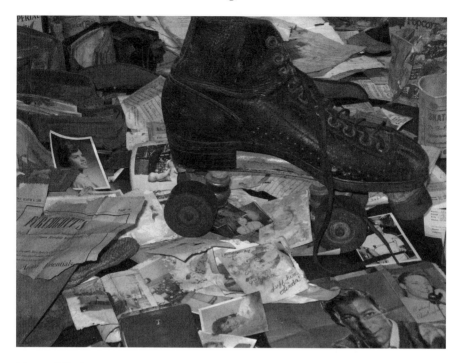

Memorabilia found behind the men's room wall at Skateland. *Photo by the author.*

where skaters had left their street shoes, wallets and pocketbooks. For many years, this evil went on undetected until one day (and this we can only surmise because the latest dated material is from the early '60s), the culprit was caught, fired or simply moved on.

As I looked at the table, I was overwhelmed by the variety of items there. I could see old-style library cards with the little metal rectangle with an embossed number on each. I could see Social Security cards, a Trailways Bus schedule with a route to the beach and quite a stash of empty liquor bottles, the kind that were just small enough to be smuggled into the rink undetected. There was a black leather man's roller skate, a left shoe, size 9. There were also many Dr. Kildare and Ben Casey trading cards smiling through the debris. Along with paper cups that lined the back of the table, a pretty racy magazine was just visible under other papers. An empty, dusty cloth bag marked $250.00 QUARTERS/ATLANTIC NATIONAL BANK OF JACKSONVILLE lay across the table.

A '50s and '60s River City Childhood

When the stash was first found, Goodwin notified Kyle Meenan, who was then a reporter for WTLV's First Coast News. Presently, Meenan, fifty-one, is an event coordinator at PRI Productions, and he provided me with a tape of a broadcast that aired on the eleven o'clock news broadcast of April 18, 2008. Meenan talked about this very memorabilia found in the bathroom wall of Skateland. The film footage showed the holes in the wall and many of the items and pictures that were discovered. Meenan even encouraged viewers who knew anything about the items to call the station. Sadly, no one ever did.

Goodwin allowed me to comb through all that was on the table. Interspersed throughout the pile were letters, the kind that we used to pass to one another during class. I eventually got to read them all. These written-on-notebook-paper epistles swept me immediately into the day-to-day lives of kids from long ago—kids doing homework while listening to the radio, kids going to detention for talking out of turn, kids going to church, kids going horseback riding, kids rooting for the home team and kids looking for true love.

One representative example was written by a girl named Nancy. It reads:

> *Karen,*
>
> *Hello! How are you. Fine?? Well how nice! Cause I'm lousy! I'm tired! Ain't ya proud of me writing you a note! Well, I knew you would be so that's the only reason I'm writing you a note. "England Swings" is on the radio.*
>
> *YEA RAMS!*
>
> *That's the mighty seniors at Englewood! Us lowly underclassmen ain't nothing. Of course only Buddy Paul said that. I hate him! I swear I do!*
>
> *Be back I have to eat supper!*
>
> *Guess what? I ate supper and got ready to go to church! Well now I'm home from church! Look I'll see you later.*
>
> *Be extra good*
>
> *Luff ya*
>
> *Nancy*

While it was thrilling to get a peek into the very private lives of these normal and ordinary young people, I was saddened, especially when I realized that by now some of these people might not even be alive. However, I chose to put these letters and the lives they revealed into a happier context.

Had letters like these not been in purses and wallets stolen out of the lockers at Skateland and hidden in a wall for decades, they would probably have been discarded. No one would get to remember that Debbie loved Terry or that Robin broke Linda's heart. No one would know that Dan, who called himself "Aces and Eights," wanted Susie to go out with him or that Butch loved Renee and that he wrote SWAK (Sealed With A Kiss) at the end of his letters to her. And no one would know of how Dalia was driving poor Jerry to distraction. In a mysterious way, the unfortunate theft of wallets has unintentionally immortalized these wonderful people and made us who have found their stories feel the flush of youthful passion, if only for a moment.

When Goodwin and I were winding up our interview, he showed me one last interesting item. It was a silver Zippo lighter that had been taped shut. Inside it were dozens of light-anywhere match heads. A hole had been drilled into the top of the lighter, and a wick of some kind had been inserted into the hole. It took Goodwin a while to figure out what this item was, but eventually he concluded that it was an "incendiary device." It looked as if it had been lit and thrown in on top of all the "evidence" hidden in the wall. Thankfully, the wick went out before it could do any damage. Otherwise, Goodwin would not have made this remarkable discovery, and we might not have this wonderful time capsule of things. As a matter of fact, we might have lost the building itself.

It is a sad commentary that criminal acts occurred in such a happy place to such innocent people, but having this collection of everyday items from the past was a strangely happy outcome. Looking through all the "valuables" of kids from an earlier time was, as Goodwin said, "humbling." And it was quite a privilege to have access to the many secret things people take with them wherever they go.

I couldn't end my discussion of Skateland without mentioning another exciting part of the time capsule found in the men's room wall—the

photographs. All kinds were tucked into the wallets, and many had been pulled out to discover the identities of these victims of theft. Goodwin allowed me to take the collection of memorabilia from his office so that I could more easily research the items in my home. I decided to invite Betty Stafford, the avid Skateland skater in the '60s whom I had interviewed earlier, to come over to my house so that we could go through all the photographs and see if she knew any of these people.

As Betty and I carefully sifted through the pictures, we discovered that many of them had been damaged and discolored by water and mold from being between damp walls all those years. Many pictures were also stuck in the brittle plastic picture cases of the wallets. Too many images were essentially lost. Thankfully, many more pictures survived, and occasionally we were overcome by the poignancy of being privy to the lives of people who were young more than fifty years ago.

There was a picture of Nancy Glaze as she rests her head upon her hand, and another of two boys named Ronnie and Benny (I am not totally sure these names are correct; the faded names on the back had been obscured by a lipstick print, as if someone had kissed the back).

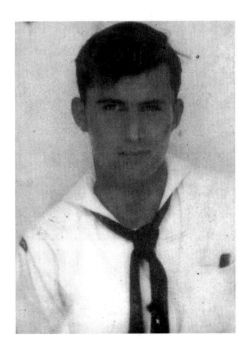

A picture booth photo of Steve Penotti Baneski. *Courtesy of PRI Productions.*

Polly Johnson just gives us a sweet smile. Betty and I especially liked the picture booth photo of a young sailor named Steve Penotti Baneski, whose face seemed to capture the peak of his youth.

We also found the ubiquitous "pony picture," one taken by the guy who used to walk a pony through Jacksonville neighborhoods so excited children could have their pictures taken with it. This picture had a little boy and a little girl missing her two front teeth sitting in the saddle. Even though the badly damaged picture had been dampened and wrinkled in the wall hiding place, there was no denying that the kids in the photograph were having a wonderful time. The pony? Well, it was hard to tell.

We examined several portraits of unnamed and beautiful girls showing the latest styles in hairdos. Some of the pictures had names written on the back, like the one of Jeannette Free. The essence of youthful exuberance was clearly evident in each of her formally posed shots.

Another batch of photos had been taken by nonprofessionals. One very sweet photo had the words "Maude and Frank when just got married" on the back. The folded and faded picture was of a young couple in a passionate embrace. They were standing behind a 1955 Chevrolet, which was next to a 1953 Ford. Two little dogs trotted about near the couple's

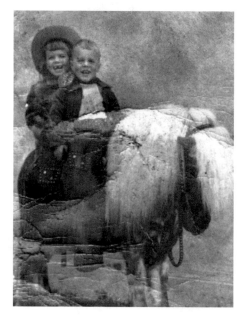

A picture of children on a pony that a photographer led through neighborhoods in Jacksonville for children's portraits. *Courtesy of PRI Productions.*

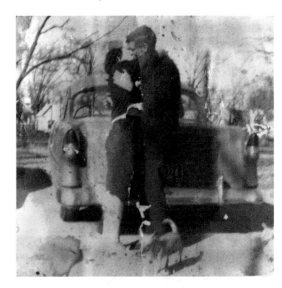

A picture of Maude and Frank on their wedding day. *Courtesy of PRI Productions.*

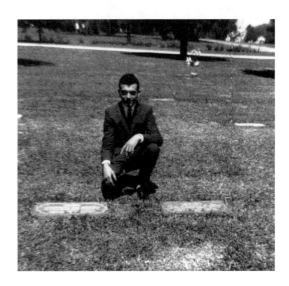

A picture of Floyd, twenty-one, as he kneels in a cemetery next to two markers. *Courtesy of PRI Productions.*

feet. The weather looked like a cold and wintery Jacksonville day, but the young couple seemed oblivious to all around them.

Another poignant picture was of a young man kneeling between two grave markers. On the back was written, "Floyd, 21 yrs old." I could not help but wonder whose graves "Floyd" knelt near. Or was Floyd one of the markers? And why would anyone carry such a picture?

A picture of Joyce Ann, who was Betty Stafford's friend. *Courtesy of PRI Productions.*

Suddenly, Betty Stafford and I came upon a picture of a teenage girl with pointy-rimmed glasses. "This was the girl I was telling you about!" Betty cried. "It's Joyce Ann! Oh, my gosh! It was her mother who made my skating outfit. I can't believe it! I just can't believe it!"

Delighted after finding a picture of a person one of us actually knew, we could hardly wait to get through the rest of the pictures. A while later, we were lucky again. We came across a newspaper clipping of a picture of Bobby Gillespie, an Englewood Rams football player. Betty was again quite excited at our find, since she had known Gillespie in high school. What a fun time we shared!

Some days later, after Betty and I had gone through all the photos, she forwarded me an e-mail she had received from the person whose picture we had found and whose mother had made her a skating outfit many years ago—Joyce Ann Diegle. The e-mail reads in part as follows:

A picture of Bobby Gillespie, an Englewood Rams football player. *Courtesy of PRI Productions.*

Hi Betty,

What a surprise and thank you for the article about Skateland. Wow what memories this story invoked! I thought for a minute that the Skateland building had been torn down, but as I read the article I learned about the "time capsule" and my picture was part of the capsule? How interesting.

We did spend some fun times at Skateland with the youth groups at church and other organizations. I didn't know Tony was a DJ at Skateland on the weekends. I bet he has lots of memories…

Thanks again for sharing this story with me.

Love,
Joyce Ann

It often amazes me how interconnected we human beings are, and that by looking into the past, we can often get an interesting view of the present. We not only get to reconnect with our younger selves, but we can also reconnect with people who shared those past times with us. At least, that's the way it seemed to Betty Stafford and me.

The Wonder of the Haydon Burns Library

In looking back at those years when I was growing up in Jacksonville, I should mention the many hours I spent doing schoolwork. As I recall, homework and projects seemed to dominate my life when I was a teenager, as I am sure it does for the lives of all teenagers. In my day, we were always writing history papers, composing English essays or muddling through science projects. In the pre-Internet world of our youth, research was done by poring over books and flipping through periodicals. What we couldn't find in books at home or at school, we found downtown at the Haydon Burns Library.

It was not unusual for my friends and me to take the bus or family cars to the dazzling new Haydon Burns Public Library, which seemed right out of Walt Disney's Tomorrowland. What a magnificent place! The building, designed by Taylor Hardwick of Hardwick and Lee Architects and built in 1965, was "ultra-modern," as my father would say, a hint of displeasure in his voice. I thought the building was great! It was visually exciting, with rippled buttress patterns that encased the top floors, bold colors and sculptural brickwork on the ground floors and sweeping open staircases. The whole place was bright and airy, and it had so many books that beckoned me to take them from the shelves and thumb through their pages.

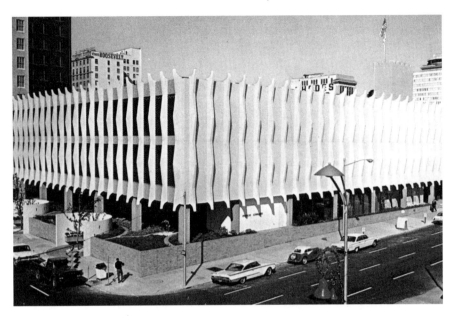

A postcard of the Haydon Burns Public Library, circa 1965–70. *Courtesy of the Jacksonville Public Library's Florida Collection.*

There was also a dark area—the basement—my favorite place to go. I loved that there were thousands of old magazines I could browse, sometimes to get ideas, but mostly I loved this space because it held the chronicles of lives in the past. It smelled of antiquity, of old paper and dusty publications, and it was cool and comfortable down below street level, something that our homes might not necessarily be during certain seasons.

I loved the Haydon Burns Library, and I was not alone. One person who was exceedingly fond of this library was the man for whom it was named, W. Haydon Burns, the mayor of Jacksonville from 1949 to 1965 and the thirty-fifth governor of Florida from 1965 to 1967.

Eleanor Burns Watkins, his daughter and a retired Duval County history teacher, said, "My father was very proud of the library that was named for him. Anything that had to do with furthering education was important to him. He had six inaugural balls held throughout Florida when he was elected governor, and the admission to the balls went to scholarships."

Watkins had many other stories to tell, saying that being the mayor's daughter provided her with a unique education. She got to meet many visiting dignitaries, such as Alben Barkley, the vice president for Harry Truman. She even got to meet John Kennedy and Richard Nixon, who both came through Jacksonville on the same day, October 18, 1960.

Fleming Island resident Robyn Lee Meares, fifty-three and a correctional probation specialist for the Florida Department of Corrections, also has a very personal connection to the Haydon Burns Library. Meares said:

> *The library holds a dear place in my heart, as I am the daughter of W. Mayberry Lee (deceased in 1972). He was the Lee of Hardwick and Lee Architects. Thank you for taking the time to remember fondly a building that so many have criticized. My father played an integral role in the design of this building, so I share a lot of pride in his and Taylor's work. I was fortunate enough several years ago to attend a presentation at UNF—fifty years of architecture by Taylor Hardwick. A lot of my father's and Taylor's work was featured.*

Of course, as often happens in life, Jacksonville slowly began to outgrow the Haydon Burns Library. By the turn of this century, there was need for more conference space, more parking spots and better wiring to accommodate computers. Almost forty years after the Haydon Burns Library was built, a new and larger library opened a few blocks away.

Even though the new Main Library is elegant, spacious and a place I love to visit, the old Haydon Burns building remains a uniquely beautiful piece of architecture that still takes my breath whenever I see it. Thankfully, there is a movement afoot to preserve this historical landmark and remake it into a viable piece of the downtown fabric.

According to William Cesery, fifty-eight, the president of Cesery Companies, plans are being negotiated to redevelop the building to accommodate several types of businesses and shops for patrons who work and/or live in the downtown area.

When I asked him why he likes to renovate old buildings, as his company did with the old Southside Grammar School, now The Lofts,

Cesery said, "For one thing, I love doing this sort of thing. It is nice to be a developer who everyone roots for because you save a landmark building. It is much better than being the type who gets vilified for cutting down pine trees off the interstate. It is much nicer to give an old spot new life, and right now, the library is our focus."

Antonio Allegretti, forty-one, is a senior consultant for Keymer, a public affairs firm, and he said, "There is a plan in place that features stall space for antiques, arts, and other collectibles and goods. There will be spaces for unprepared food—a butcher, fish monger, etc.—and prepared food including coffee, lunch and dinner, etc. There is, on plan, a large gathering space for live events and music that will open to the huge patio Biergarden. The plans aren't quite done, but these ideas are a good representation."

So we must watch and wait for things to happen with the Haydon Burns Library building. Then, my friends and I can rest assured that places that once held great importance in our lives can have new incarnations for our children and our grandchildren, especially a place as modern and cool as the Haydon Burns Library.

The Monumental Impact of Miss Chic, Jacksonville's First Elephant

I was just thirteen on November 10, 1963, when I grabbed the *Florida Times-Union* from the breakfast table that morning and read about an unexpected death. Miss Chic, Jacksonville's first elephant, had died. The obituary-like article said that the forty-year-old pachyderm had been dealing with heart problems for quite a while, but before she died in her sleep that November, with her elephant friend Miss Debbie at her side, Miss Chic had been amazing Jacksonville children since she was three.

Miss Chic was born in 1923, the same year as my father, and within three years of her birth, she had traveled from her birthplace of Calcutta, India, to Hamburg, Germany, and then to the fledgling Jacksonville Zoo in north Florida. According to the article, "Crowds awaited her arrival at the docks on June 10 [, 1926]. Newton P. Baldwin, zoo director, said that nickel and dime donations accounted for much of the $3000 price paid for the 3 year-old elephant. She was escorted to her new home by many of the boys and girls on bicycles."

George Prom is eighty-eight now. He graduated from Robert E. Lee and Stetson University, is a veteran of World War II, is a retired Baptist preacher and now is a writer. When he was very little, he was one of the first of Jacksonville's children to have a Miss Chic encounter. Prom said:

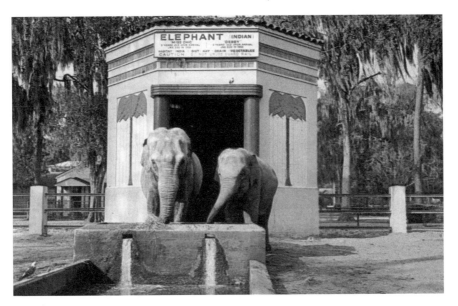

Miss Chic (left) and Miss Debbie in front of the Elephant House at the Jacksonville Zoo. *Courtesy of FLAJAX.com.*

I believe it was in 1926 when I was a little kid about three years old. Mrs. Rawls, a good neighbor of the family, had provided material to my mother for her to make me a third birthday outfit. Floral material was used to make the shirt, and the blue material was used to make a pair of shorts. On my birthday, my mother dressed me in the new clothes, and my father took me to the zoo so that I could see the new little elephant, Miss Chic.

Boys were selling five-cent bags of peanuts, and we bought a bag, maybe two. Then we stood at the iron rail fence where the elephant was. Papa held me up, and I held out my hand with a peanut in it. She came right up to me and lay her trunk on my knees. Before I knew it, she had sneezed or snorted all over my brand-new clothes. I began to cry.

When we got home, I told my mother that Miss Chic blew her nose on me. I'll never forget that.

Miss Chic got her name from City Commissioner St. Elmo "Chic" Acosta, the man for whom the Acosta Bridge is named. In a newspaper editorial written in 1925, Chic Acosta's effort to get an elephant

for the zoo was called a "monument to persistency." When the city commission would not budget for the elephant, Acosta turned to "public subscription"—pennies and nickels from the children of Jacksonville, donations from church benefits and even a Ford automobile.

Atlanta resident the late Mark Acosta was the grandson of "Chic" Acosta, and Mark was quite proud of his grandfather's legacy. I was most fortunate to have an interview with him in 2010, about six months before his death on July 3 at the age of fifty-five.

In the interview, Acosta told me, "I only knew my grandfather from my father because my grandfather died in 1947 before I was born; but I was told he was a very colorful, strong-minded, strong-willed political leader. He was a proponent for beautifying Jacksonville, and as the commissioner of parks, he arranged for the purchase of forty acres on the Trout River to be used as a zoo."

Acosta went on to say, "As I was growing up, Dad would take us out to the zoo two or three times a year. He'd say, 'There's the elephant named for your grandfather.' I also remember feeding Miss Chic peanuts and watch[ing] them get sucked up in her trunk only to have her hold out her trunk for more."

Many others remember feeding Miss Chic peanuts and marveling at her amazing trunk. When I was in elementary school, we loved traveling to the Northside to the Jacksonville Zoo on one of our annual field trips. Of course, no trip to the zoo was complete until we stopped by the sturdy Art Deco elephant house designed by Roy A. Benjamin.

Former Jacksonville resident Dave Allan, sixty-three, of Pensacola, told me in an e-mail:

> *The highlight for me going to the zoo, as a child in the '50s, was my dad buying me a brown bag of peanuts at the gate and going straight to the elephant house to feed Miss Chic.*
>
> *I recall on one visit my dad bent over the guardrail to feed Miss Chic, and his sunglasses fell out of his pocket. Miss Chic reached right down, and to the horror of everyone around, she picked them up with her trunk and commenced to eat my dad's sunglasses. My dad found an elephant attendant and told him what happened. The attendant laughed and*

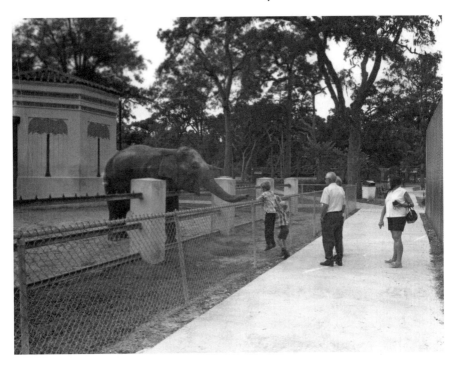

Miss Debbie is entertaining children in front of the Elephant House at the Jacksonville Zoo, 1970. The Elephant House was designed by Roy A. Benjamin. *Courtesy of the Florida State Photographic Archives.*

said, "Don't worry, she loves to chew things and will probably spit them out." She did, and I guess they were none the less for wear.

As my friends and I moved out of childhood, we didn't hang out at the zoo anymore. Still, when news of Miss Chic's death ran in the newspaper, I was really sad at the passing of such a noble beast.

Allan Ross, the unofficial historian of the Jacksonville Zoo, says that Miss Chic was buried on the same day that she died, right outside the front gates of the zoo. Since the entrance to the zoo has been moved, no one on the present staff knows exactly where the grave site is. Her grave was never marked, but Miss Chic certainly left a huge impression on hundreds of thousands of Jacksonville children, and that, after all, is enough of a monument for any life.

A River Runs Through It
and Many Bridges Connect It

When my family first moved to Jacksonville, my father used to do the most embarrassing thing. He would get out of our car whenever the crossing arm of the Fuller Warren Toll Bridge went down. He would then move down the center line to the edge to watch the spans move up and down. His gawking at this marvel of industry only made me want to slide down low in the car seat so no one nearby could see me or my humiliation. My father was undeterred, however. He couldn't get over the magic of bridges.

I wasn't as much taken with the mechanical aspects of things as I was with the beauty that surrounded us—like the glistening, powerful St. Johns River below us. As I awaited my father's return, I let cool breezes carry the sound of gulls to me, while I imagined what it might be like to be on the deck of the boat that caused the bridge to go up in the first place.

Now, I realize that Jacksonville provided both my father and me with many wonders—a river for me to enjoy that was far more beautiful than the Mississippi back in East St. Louis and many magnificent bridges for my father to inspect. It seemed the perfect combination.

The first bridge to span the St. Johns River near Jacksonville opened in 1921. At that time, it was not named for anyone. It was simply called

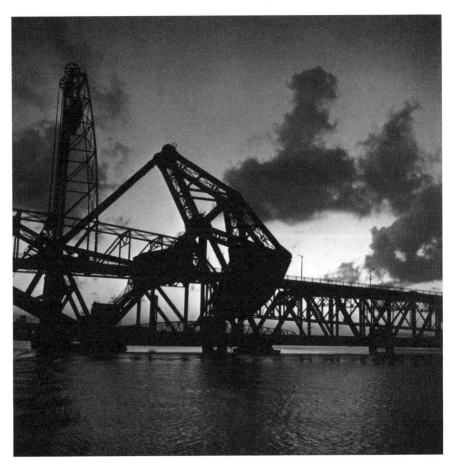

The St. Elmo W. Acosta Bridge, complete with railroad trestle, 1968. *Courtesy of the Florida State Photographic Archives.*

the "Jacksonville/St. Johns River Bridge." According to an article in the *Florida Times-Union* that ran on August 18, 1949, the bridge was renamed St. Elmo W. Acosta Bridge. The article said that Acosta, "the late city commissioner and legislator, was the so-called 'father' of the span." This is the same civic leader for whom the Jacksonville Zoo's first elephant, Miss Chic, was named.

When I was little, crossing the St. Elmo W. Acosta Bridge meant we were headed to Riverside and the Children's Museum at 1061 Riverside Avenue. Or we might have been headed to Worman's Delicatessen or the Jacksonville Train Terminal, now the Prime F. Osborn III Convention

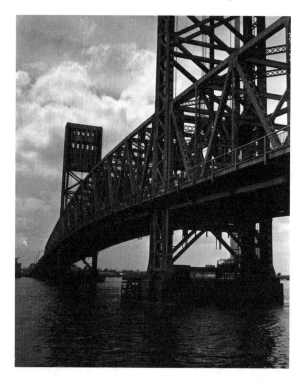

The John T. Alsop Jr. Bridge, more commonly called the Main Street Bridge, 1960. *Courtesy of the Florida State Photographic Archives.*

Center. At one time, this bridge had three lanes, with a streetcar using the tracks in the middle lane. In my youth, the streetcar was gone, and in the early 1990s, that bridge was replaced with a sweeping concrete span, with the People Mover running down the center.

Another of Jacksonville's bridges is the Main Street Bridge, also known as the John T. Alsop Jr. Bridge. It was the second bridge to cross the St. Johns when it opened in July 1941. Ever since, it has served as the symbol of our city, even emblazoned on the Super Bowl XXXIX logo in 2005 when that game was contested here between the New England Patriots and the Philadelphia Eagles on February 6.

As a kid, the Main Street Bridge was my path to downtown and all the wonders that were there—Cohens, JCPenney's, Ivey's, Woolworth's, Furchgott's, Abe Liverts, Phelps Fabrics, Paulus Music Company, the Stand'n'Snack and the Haydon Burns Library. As an adult, I have treasured memories of taking my children over that bridge and our making a humming noise as we crossed the drawbridge section. And

who could forget the night we could all walk over the lighted blue bridge during the Super Bowl as fireworks exploded behind it? What a wonder!

Jacksonville's next bridge to be built was the John E. Mathews Bridge, dedicated on January 1, 1953, about one month before it was finally completed. Florida Supreme Court justice John E. Mathews was there to officiate at the ribbon-cutting ceremony, according to an article in the *Florida Times-Union* published on January 2, 1953.

For me as a teen, the Mathews Bridge meant I was headed to the brand-new and exciting Regency Square Mall out in Arlington or the Town and Country Shopping Center, complete with the Town and Country Movie Theater. We might even go all the way out to Jacksonville University, where my mother went to attend classes for her bachelor's and master's degrees. My siblings and I loved the beautiful campus, where she would let us play while she did research in the Swisher Library.

I suppose the most important bridge in my life is the Fuller Warren Bridge, the one my father enjoyed so much. The *Florida Times-Union* ran

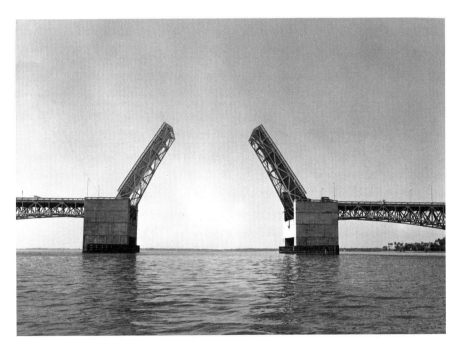

The Fuller Warren Drawbridge, 1954. *Courtesy of the Florida State Photographic Archives.*

an article on June 7, 1954, announcing the opening of this bridge. The article said that, at the time of its opening, the bridge was called the Gilmore Street Bridge. On December 8, 1954, another article in the *Florida Times-Union* announced that the State Road Department was renaming the new Gilmore Street Bridge for former governor of Florida (1949–53) Fuller Warren.

For about nineteen years of my life, I traveled the Fuller Warren Bridge to and from work. During my college summers, I worked as a waitress at either the Lane Avenue or the Golfair Boulevard Howard Johnson's Restaurants. I had to pay fifteen cents' toll both ways, which I had readily available from my tips.

For the twelve years that I taught English at Edward H. White High School and the five years I taught at William M. Raines High School, I had to go over the Fuller Warren every morning and afternoon. My toll contribution alone should have paid for at least one square foot of that bridge. Oh, how I remember so many afternoons when I perspired profusely as I sat in slow-moving traffic on the bridge near the tollbooths. I didn't always have air conditioning in my car, so with the humidity high and the smell from the Maxwell House Coffee Plant permeating the air, I could easily imagine myself floating in a cup of hot coffee.

No one was happier than I when the tollbooths were finally dismantled and the tolls eliminated in 1988. (Thank you, Mayor Tommy Hazouri.) It wasn't long after, however, that I was transferred to Samuel W. Wolfson High School on the same side of the river as my house.

Then, in 2002, the Fuller Warren became a beautiful modern span with no drawbridge. Even though it is so much more efficient, my father would have thought it had "lost something in the translation."

The Isaiah D. Hart Bridge was the next bridge to be constructed, and it provides spectacular vistas of the city. This bridge was opened on November 2, 1967. According to the *Florida Times-Union*, Jennifer Fewell, who was eight years old and the great-great-great-great-granddaughter of Isaiah D. Hart, "the father of the city," was present to cut the ribbon to open the bridge.

This bridge has always taken me to football games at the Gator Bowl or concerts at the Coliseum (although I sometimes took this bridge to Raines

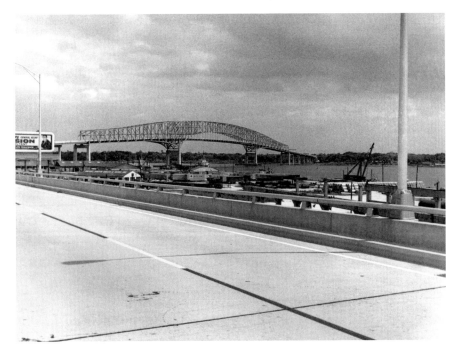

The Isaiah D. Hart Bridge, 1970. *Courtesy of the Florida State Photographic Archives.*

High School, especially when there might have been an accident on the Fuller Warren). Now it is my path to Jaguar games and tailgating, and there is no finer view of our city than the one from the Isaiah D. Hart Bridge.

The Henry Holland Buckman Bridge was opened on May 1, 1971. The *Florida Times-Union* article on May 2, 1971, said that Henry Holland Buckman was a former Jacksonville legislator who authored the Buckman Act of 1905, consolidating the state's existing colleges into three universities. He also helped establish the Board of Control for the universities, the forerunner of the Board of Regents. The article went on to say, "Opening of the bridge had been delayed since 1969 by exploding pilings, re-bidding of repair work and unfavorable weather conditions." Apparently, polluted water had been reacting with the cardboard-lined center of the pilings, which caused them to explode. Thirty-two pilings had been damaged.

Still, I love the Buckman Bridge because I have experienced it from above and below. When I traveled above, I was on my way to someplace

fun—like to lakes in Keystone Heights, to Girl Scout Camp Chowenwaw in Green Cove Springs or to the Orange Park Mall for a movie. When I traveled below the Buckman, I was aboard my husband Hardy's sailboat spending the day on the water.

Finally, the most dramatic of all Jacksonville bridges has to be the Dames Point Bridge, which opened on September 24, 1988. It towers over the water, with its suspension cables carrying the eye up even higher. It is a breathtaking sight, indeed.

One of the dearest stories connected to any of the Jacksonville bridges was the story about Kimba, the seven-year-old Jacksonville Zoo elephant, which got to be part of the parade over the Dames Point Bridge at the opening ceremony held at nine o'clock in the morning. While reading about this in the *Florida Times-Union* of September 23, 1988, I was touched that Jacksonville, even as it grew more and more sophisticated, still thought to provide such a rare treat for the children—an elephant leading a parade. Reading this story also gave me a strange, satisfied sensation as I made the connection between bridges and elephants and Jacksonville.

My first experience with the Dames Point Bridge came later, as I traveled over it on the back of my husband's Yamaha Road Star motorcycle. We were headed to Fernandina to visit friends, and I can still feel the thrill as we roared over the mountainous expanse of the Dames Point Bridge.

Jacksonville is certainly blessed with many wonderful bridges. I have not mentioned all of them here, just those that cross the main part of the river. Still, my father would have loved to get out and walk every span of Jacksonville's bridges, if only the traffic or the embarrassed little girl he took with him would have allowed him to do so.

John Saare's Vision of Sailboats Led to Mug Race

W hen I was thinking about the bridges of this city, I realized how blessed we are in Jacksonville to have such a magnificent river in the middle of our lives. I'll never forget what a dazzling sight I got to see one day when I was driving over the Buckman Bridge from Mandarin to Orange Park. Below me and my car were hundreds of white and multicolored sails billowing on the glittering St. Johns River. As far as the eye could see, sailboats skimmed the surface of the water, looking like a swarm of giant butterflies.

Later, I found out I had witnessed the end of one of the Mug Races sponsored by the Rudder Club of Jacksonville. As the fifty-eighth annual Mug Race approached on Saturday, May 7, 2011, I couldn't help but feel lucky to live in a place that provides such marvels.

Sally Griner, sixty-seven, a longtime Jacksonville resident, had some firsthand knowledge of the Mug Race: "I have some wonderful memories of when John and I climbed aboard one of our friend's big boats, and we would sail down to Palatka on Friday, spend the night on the boat and then watch the smaller boats take off for Jacksonville in the Mug Race."

Such great Mug Race memories would not have been possible for anyone, however, had it not been for a forward-thinking shop teacher at Landon High School back in the 1930s. John Saare, a transplant

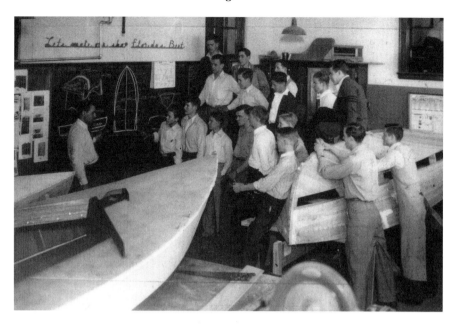

John Saare conducting one of his shipbuilding classes at Landon Senior High School. *Courtesy of Donna Mohr, commodore of the Jacksonville Rudder Club.*

from Minnesota, began the first accredited high school boat-building class in the United States. He was responsible for the formation of the Rudder Club.

According to an April 20, 1966 *Florida Times-Union* article by Fran Mollnow, Saare felt a distinct disappointment the first time he saw the St. Johns River, where "not a sail was in sight in any direction." He had grown up near Lake Superior, where sailboats and sailors were plentiful. Saare began talking about sailing with his students, and when a number of them expressed an interest in building their own crafts, he started the sailboat-building class.

The article went on to say, "By the end of the 1940 school year, six Landon boat-building students launched their 14-to-16-foot crafts in the St. Johns and raced across to compete in the Rudder Club's first regatta."

According to Jeanne Greek, a retired French/Spanish teacher in the Duval County school system, "My brothers, Albert and Stanley Smith, spent many happy hours renovating and sailing a sailboat built in one of John Saare's classes. They had bought the craft from Herb Cochley, and

after making appropriate repairs, which included sanding and warping a lemonwood mast, they put the boat in at an inlet off River Oaks Road where many boys kept their boats."

I was able to contact Herb Cochley's son, Herb, sixty-one, a self-employed engineer who lives in Mandarin, and he remembers the boat his father built in Saare's class. "My dad lived on the river in what was Smullian Trail by Bolles, and he talked about the sailboat they built at school often. But one of the boys in Dad's class died on his sailboat. Not my dad's, but his. I guess the kid got caught in a storm. It hit my dad so hard, he totally lost enthusiasm, sold his sailboat shortly afterward and walked away completely. Sad."

When World War II was declared, Saare temporarily left teaching and worked in the shipyard by day and was a U.S. Coast Guard officer on river patrol at night. He eventually would return to teaching industrial arts at Andrew Jackson High School, and then he moved into school administration after that.

The Rudder Club he had helped form began to lose its teenage members, but as time went on, the club evolved into an adult organization. Then, in 1953, the present-day property of the Rudder Club at 8533 Malaga Avenue in Orange Park was purchased for $2,000. In 1954, the first official Mug Race was launched. As the name would indicate, the prize is a huge mug.

The winner of that first race was fifteen-year-old Albert Holt as skipper and his cousin Tommy Entenza as crew. They sailed a C-class bilge-board craft. It is fitting, if not fortuitous, that fifty years later, Holt would again win the Tall Boat Race portion of the Mug Race in 2004.

When asked about his two big wins, Holt, now seventy-two, said:

Those were two wonderful days, to be sure, although there was a pretty scary squall that helped us get quickly through to the finish line [during the first race].

The people of Palatka treated us like kings. The early Mug Races were run from Jacksonville to Palatka, instead of the way they sail now [from Palatka to Jacksonville]. *And during those early races, the starting rules required that we had to be at anchor and sails had to be*

Two members of the early Rudder Club. *Courtesy of Donna Mohr, commodore of the Jacksonville Rudder Club.*

down. Sailors then had to swim to their boats, step the mast and then go. You had to be a very manly man or fifteen years old.

As sailors prepare for upcoming Mug Races and spectators plan to set out their lawn chairs to watch from the river's edges, we all owe a great debt to Saare and his vision of a sailboat-filled horizon for the St. Johns. Although his death in 2007 at the age of ninety-four marked the end of an era, his legacy is still a vibrant part in the life of one of our greatest natural resources—the St. Johns River—and as the boats sail past each May, I intend to remember that.

UPDATE: Shortly after my column about the Mug Race ran in the "Community Sun" section of the *Florida Times-Union* on April 7, 2011, I received an e-mail from a retired elementary school teacher, Charlene Touchton McEwen, sixty-seven. Her letter said, "My brother was in that

picture. I think he is the one closest to Saare. He drowned his senior year 1942. He had gone sailing alone; never knew what happened. I never knew him because I was born in 1943. My mother told me he was the first president or founder of the Rudder Club. His name was Clark Touchton, and he lived on Riverwood Lane."

I suppose Clark Touchton was the person whose death made Herb Cochley's father sell his sailboat. As I read the e-mail from Touchton's sister, I realized that one of life's cruel realities is that tragedy can strike anytime, anywhere and anyone. I was amazed by how I saddened I was by the loss of someone who died before I was born. The longer I live and the more I research things past, the more I realize how interconnected we all are.

Encountering Things Masculine

Cigars, Barbers and Firemen

O nce, when I was traveling down the Martin Luther King Jr. Parkway, I suddenly found myself reliving a memory. King Edward Cigar Company was to my left, and the smell of tobacco enveloped me so completely that I felt as if my father were again in the car, smoking one of his fragrant cigars.

I would never suggest that smoking is a good thing, since science has proven its many dangers; but in a time before we knew all of that, pipes, cigars and cigarettes were very much part of many American lives. The Internet has many sites that contain old magazine and newspaper ads touting the virtues of smoking. Some ads suggested that smoking was an almost healthy thing to do. One ad said, "More doctors smoke Camels than any other cigarette." Another ad said, "Not a cough in a carload." The ads for Prince Albert in the Can Smoking Tobacco were equally reassuring: "Declare Truce On Tongue-Bite."

Candy cigarettes sold along with Tootsie Pops and BB Bats prepared us children for lives with plenty of smoke in them. Still, even though I gave up smoking more than thirty-five years ago, I felt a bittersweet pang when I passed the King Edward Cigar Factory that day.

According to Joseph Augustus, senior vice-president for external affairs at the King Edward Cigar Company, the factory has been in Jacksonville

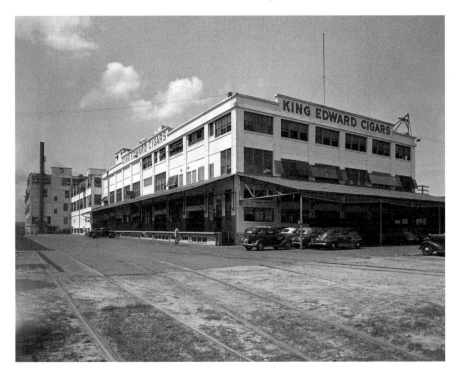

King Edward Cigar Factory in Jacksonville, 1946. *Courtesy of the Florida State Photographic Archives.*

for close to a century. Sometime around 1913, brothers David and John Swisher relocated their family business from Ohio to Jacksonville. It has remained at the East Sixteenth Street location for almost one hundred years.

"We are one of the largest employers in the city," Augustus said. "We are a family-owned company, and we operate it as such. Some of our employees have had grandfathers and grandmothers working here. The company is also a good corporate citizen. We have considerable charitable involvement, and our presence is felt on the Jacksonville University campus with several Swisher buildings."

Another place that can conjure my father's memory very quickly is Edward's of San Marco. When I walk in the door looking for the perfect birthday or Christmas gift, the smells from the back of the store waft gently up to me.

Robert Wright, the owner and cigar aficionado, said Edward's Pipe and Tobacco Shop was founded in 1969 in Arlington by Cy and June Jones.

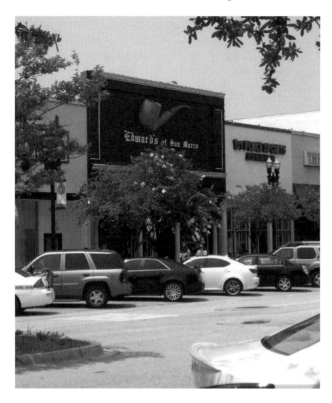

Edward's of San Marco. *Photo by the author.*

In 1983, their daughter Sandy Jones opened a second store, Edward's of San Marco, and in 2005, Wright bought the store in San Marco that he now runs. The sixty-year-old Wright got into the business because he was a cigar smoker. He grew up in the Midwest around smokers like his grandfathers and uncles. "Obviously, people's use of tobacco has changed in the last fifteen to twenty years," Wright said. "We here at Edward's have moved out of cigarette sales, and we do not carry snuff or chewing tobacco."

Dino Castillas, a fifty-eight-year-old sales associate, said, "We also do not carry Cuban cigars, since there is still an embargo. Most of our cigars are Dominican, Nicaraguan or Honduran."

Wright is often amazed at the number of women who come to the store just to inhale the aroma produced by the loose tobacco stored in jars. They also come to inhale the scent of cigars stored in a huge, room-sized humidor. He said:

These customers often say it is because the smell reminds them of the men in their lives—fathers, uncles, old boyfriends. And it is also interesting the number of women who purchase tobacco to use as a potpourri, so that they might be reminded of their deceased husbands. We even have people buy the large cedar humidors to store the cremated ashes of their loved ones.

I am sure that my father would have loved Edward's, and I know he loved his Swisher Sweets that he bought at Lakewood Pharmacy. Just thinking about it, I feel like a little girl again, remembering how my dad would always give me the foil/paper ring from one of his special cigars. It is strange that all these memories could come from the sweet smell I encountered on the way to somewhere else.

There is another "manly" sort of memory I experience when I go about the city. It usually comes rather unexpectedly, but there it will be—a twirling red-and-white barber pole signifying that a barber is open for business.

When I was growing up, there was one place where girls were not exactly forbidden, but they certainly weren't invited, either. It was the local barbershop, a haven for the male population. Once a month, my father would come home trimmed and clean-shaven. Pinaud Talc lay in a fine layer around his neck, and Bay Rum scented his cheeks. There were also times when my little brother would come home sporting his signature "buzz" cut.

Former Jacksonville resident Philip Smith, fifty-nine, a professor of history at Texas A&M University, remembers what he calls the "old-fashioned male space" provided by barbershops. He and his father went to the Old Gem Barber Shop just a block from the courthouse. Smith recalls that every couple of weeks he would walk across the Main Street Bridge after his classes at Landon High School to get his hair cut at the Old Gem.

Southside resident Yvonne Paffe, eighty-three, a housewife, offered a unique perspective on barbershops. She said:

My dad was a barber in West Virginia while I was growing up, so I've seen plenty of shops. These were the Vitalis days. But if I wanted

eight dollars for a new dress, it was beneficial to go into Dad's shop and wheedle the money out of him in front of the customers, who got a good laugh. In return, I sent several of my boyfriends to his shop.

Dad would spend winters in St. Augustine working at Price's Barber Shop until he met Mother, and they went to the mountains to live. Dad would be aghast to learn that customers these days would have to make an appointment just to get a shave and a haircut.

San Jose resident Chuck Adkins, fifty-seven, a Jacksonville CPA, recalls that when he was little, his grandfather would take him to Cliff's Barber Shop in Lakewood. "I remember the Butch Wax they put in my hair to make the front of my crew cut stay up. I also remember seeing the straight razor being sharpened and being glad I didn't need to shave yet."

There aren't as many such barbershops in Jacksonville anymore. They seem to have taken a back seat to the quick-cut, unisex, beauty parlor–

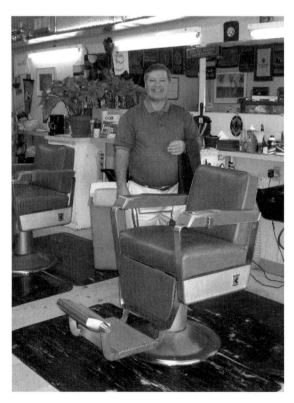

Barber Jerry Nowak in his shop on Spring Glen Road. *Photo by the author.*

type places. Still, there are a few barber poles around, spinning to tell customers that things are done the old-fashioned way. Well, maybe not as old-fashioned as when a medieval barber put out a bloodied cloth to let the populace know he was skilled in blood-letting. This tidbit of information came from the *Standardized Textbook of Barbering* (1950), a book I borrowed from Jerry Nowak, proud owner of Jerry's Barber Shop on Spring Glen Road.

Following in the footsteps of his barber grandfather, Nowak went to a barber college in Cleveland in 1969. From there, he went into the navy and served as the chief and officers' barber on the USS *Yosemite* stationed at Mayport Naval Station. The sixty-year-old said it was a great duty. "One morning, I was standing on the deck of the ship. I look over and I can see the officers' club, palm trees and the beautiful sun rising, and I said to myself, 'I am never leaving this place.' I met and married a Florida girl, and I have been here ever since."

For forty years, Jerry has been a barber, doing real estate on the side. In 1998, he bought his own shop from Wayne Albritton, who had been in business for fourteen years.

On the day I went to talk to Jerry, he was, of course, cutting a customer's hair.

"What's the password?" the customer asked.

"Golf," I said, since it was the only logical answer. How could it be anything else with all the golf towels tacked across the tops of the walls? Some towels, given by customers, were from golf courses as far away as St. Andrews in Scotland or as close as Ponte Vedra.

Along with two barber chairs, Jerry's Barber Shop has a huge rack of sports magazines and the familiar masculine smells of shaving cream and after-shave, which reminded me of my dad. Just standing there made me glad that there are still men like Jerry who honor these "old-fashioned masculine spaces," providing shaves and haircuts, even if the price is now far more than the customary two bits.

Another memory that has a very masculine feel to it is that of firemen, especially those who worked at stations near my childhood home. Today, I take it for granted that if my house catches on fire, within minutes, a fire engine filled with firemen will be at my door.

But back before the consolidation of the city and county governments, those of us who grew up outside the city limits of Jacksonville had a very different option—volunteer firemen at seventeen stations making up the Duval County Volunteers.

Tampa resident Lula Dovi, an eighty-seven-year-old retired schoolteacher, said the volunteer fire department in Lakewood was founded by her husband, Stefano, and some other men, all college grads. "They had a lot of territory to cover," she said. "A neighbor down the street kept an old LaFrance fire engine at home before the county chipped in for an upgrade. Quite often, emergency calls came through just when the members were dressed up and at a party. Very inconvenient."

Mandarin resident Tom Copeman, sixty-eight, is a retired fireman with thirty-eight years of experience with the Jacksonville Fire and Rescue Department. He said, "The air horn would sound, and a telephone tree would be activated, mostly by wives, telling the volunteers where the fire was. The volunteers would head to the station to pick up the truck and equipment and then rush wherever to put out the blaze."

In 1963, Copeman became the first paid volunteer at the Lakewood/San Jose Volunteer Fire Department at its old location on Morrow Road, which is now occupied by Dibble Roofing Company. Copeman's job was to stay at the station from 7:00 a.m. to 7:00 p.m. Monday through Friday so that he could drive the fire truck, usually a tanker, to the scene of the fire.

"In 1927, before there was a firehouse, an American LaFrance chain-drive engine was usually parked behind one of three gas stations at the corner of St. Augustine and Longwood Road [now University]," Copeman said. "As best I can recall, it was about 1958 before a fire station was built."

Copeman has many stories gathered from events in his considerable career. One difficult event was the Roosevelt Hotel fire in December 1963, when he worked for the city's fire department. He said that a fire chief died of a heart attack at the scene, and twenty-one people died from smoke inhalation.

But being a fireman had happy moments as well. Each station sponsored a yearly dance and beauty pageant—an event that provided

a balance for all that masculinity. Lakewood/San Jose Station held the Miss Blaze Contest, and the winner would compete for the title of Miss Flame with other volunteer fire station winners.

Ortega resident Loraine Pratt Nelson, sixty, was the winner of Lakewood/San Jose's Miss Blaze Contest in 1966. She then represented the station at the Fireman's Ball and Beauty Pageant in October 1966 in the Civic Auditorium. The dress was semi-formal, and there was a two-dollar donation. Although she didn't win Miss Flame, the retired Duval County principal said, "It was such an honor to represent the Lakewood/San Jose Station. Since neighborhoods were small back then and everyone knew each other, it really meant a lot to me to be able to help with station events and to represent my neighbors and my friends."

Loraine Pratt, the winner of the Miss Blaze Contest, 1966. *Courtesy of Loraine Pratt Nelson.*

I marvel at how many good people in the past dedicated their time and energies and even risked their lives to protect us and our neighborhoods. It is also nice to imagine the Fireman's Ball and all the lovely contestants as they modeled swimsuits and evening gowns. Because the volunteer firemen had dedicated themselves to providing this unselfish service, such fun times were possible. We owe these volunteers a great debt.

UPDATE: On December 16, 2011, Robert J. Wright, owner and proprietor of Edward's of San Marco, passed away at the age of sixty-one.

Encountering Things Feminine

Aprons, Garden Clubs and Virginia Atter Keys

When it came time to clear out my parents' house to sell, my sisters and I found something special tucked away in the linen closet between the pillowcases and the tablecloths. It was a small, plain apron I had made with my own hands in home economics class forty years earlier. The little apron had, at one time, been a bright orange floral pattern, but now it was faded and the seams puckered from age. I was surprised that my mother had kept it, since she was not a sentimental type.

As I held the frail piece of cloth in my hands, all sorts of high school memories came back to me—of flaky biscuits we used to make, of the zippered dresses we had to sew and then wear to school as part of our grade and of the heavenly smells of made-from-scratch chocolate cake that filled the halls of Wolfson High School on baking day. Making these things was just part of the curriculum of home economics classes that girls in the '50s and '60s were required to take in public school. Now, as we have progressed as a culture, we have put aside such "quaint" activities, much as we did our unflattering white gym suits, as so much unsophisticated foolishness.

Southside resident Patricia Wallace, a retired home economics teacher who taught at Wolfson for twenty-eight years, laughed when I mentioned the apron project. "Oh, my," she said. "It was a good activity meant to teach students how to sew a straight line."

Pat Wallace, home economics teacher at Wolfson High School. *Photo from the 1968* Rhombus, *Samuel W. Wolfson High School's Yearbook.*

Wallace, who is seventy-seven and volunteers at Mayo Clinic every Friday morning, gets to meet all kinds of people from all over the world, even many of her former students. "Once a woman came up to me and told me that I had been the one who taught her how to cut up a chicken. I asked if she thought that had helped her save any money, and she assured me that it had."

As we talked about events and people we knew from her time at Wolfson High School, I mentioned the dresses we were required to make. "Some of my colleagues required the girls to wear their projects, but I didn't make my girls do that if they didn't want to," Wallace said. "But teaching home economics was so much fun, especially in the early days. Kids wanted to be there, even boys. Many of them wanted to learn how to cook for when they went off to college. We had so many boys sign up one year, we had to schedule some out."

Chris Force, forty-six, director of career and technical education for the Duval County school system, said the state now requires each high school student to take either one fine arts or one practical arts course for graduation. Traditional home economics classes, with cooking and clothing construction, no longer exist at most Duval County high schools.

"Home economics has morphed into new courses in the mass curriculum," Force said. "Cooking has become 'culinary arts,' and clothing construction has become 'fashion merchandising' or 'fashion design.' The idea was that the county wanted to provide students with a seamless pathway into the Jacksonville economy with the kind of classes that can provide industry credentials."

It is comforting to know that some of our children will find occupations that allow them to design new lines of clothing or be able to prepare banquets in restaurant kitchens. But with the hectic nature of our lives, I wonder who will teach ordinary people how to hem up their pants or bake biscuits for their children?

I think we often lose a little something as the world progresses. Moving away from the "June Cleaver" experience that home economics classes provided may be a step forward in our evolution, but I lament the loss of such wholesome activities as baking casseroles and sewing straight lines. And those special little aprons, once meant to keep our Villager or Bobbie Brooks dresses clean, will disappear forever from the kitchens (or the linen closets) of the world.

Along with home economics, another usually feminine institution has "morphed" into something very different. Garden clubs were quite prevalent in the '40s to the '60s, and they were often very much a part of a southern woman's schedule.

Not long ago when I was surfing the Internet, I came across a wonderful photograph of women from the late '40s. They were members of a distant Florida garden club, and they were enjoying high tea outdoors. As palm fronds swayed in the background, these women filled their tea cups and added petit fours to their plates. They stood proudly in Sunday dresses, complete with strings of pearls, hats and white gloves in hand. How could I not be impressed by such devotion to fashion even in the Florida heat?

This photo was another gentle reminder of my mother and her influence. She knew how to dress fashionably. We have photos to prove it, but she also knew how to negotiate the politics of bridge clubs and coffee hours, all while rearing four children and growing a garden fit to be featured in *Southern Living* magazine.

Many women of her generation became involved in garden clubs along with their church circles and PTA meetings. Being a member of a garden club allowed women an outlet for creativity that then could be carried home and used in their own gardens and yards.

One such garden club still operates today on Loretto Road. The Mandarin Garden Club was founded in the '40s, when Mandarin had about three thousand residents. Even though times have certainly changed, some things have remained constant.

Alice Jones-Stanley, a member of the club since 1969, said the garden club was founded in 1945. Her aunt, Mable Woolfe, was an early member of the organization. "The Mandarin Garden Club was a group of thirty or so homemakers who wished to preserve the magnificent oaks and

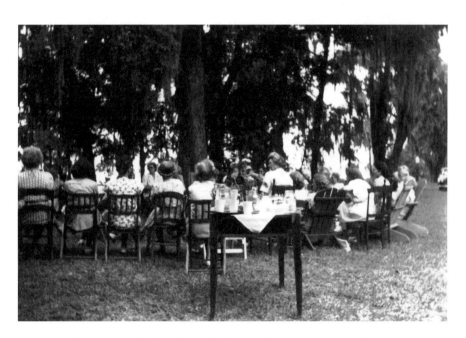

Mandarin Garden Club picnic at Brady Park, 1949. *Courtesy of Mandarin Garden Club.*

beautify the community of Mandarin," Jones-Stanley said. "They had to finance themselves with fundraisers like the yearly Fall Festival."

Mary Howe, also a Mandarin resident and club member, said the club sponsors a Trash-to-Treasures event and plant sales, and it rents out its hall for nonpolitical and nonreligious receptions. She said Bert Foshee, a lifetime member and president from 1961 to 1963, was able to get her contractor husband to build the present building for a greatly reduced construction price. In 1987, members burned their clubhouse mortgage.

As I thumbed through some old club documents and scrapbooks, I found a wonderful picture of garden club members in 1953. These women were in costume for one of their fundraisers, and they were posing on the front steps of the Athletic Club of Mandarin. This was their meeting place before they had their own building, and they shared it with the Mandarin Community Club.

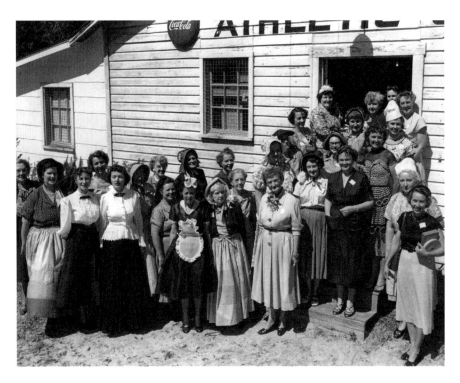

Mandarin Garden Club, 1953. *Courtesy of Mandarin Garden Club.*

These women were to manage booths for the first annual Country Fair and Flower Show. It was held over a two-day period in April 1953. Some of the women in the picture commemorating the event were dressed as pioneer women. Others came as French maids and chefs, and some wore Sunday dresses with bead necklaces and corsages. All seemed to be having a grand time.

A brochure circulated at the event told of farm exhibits and booths of flowers, potted plants, fruits and vegetables. There were also household demonstrations for proper canning and preserving techniques. The brochure also promised, "Games for the young, the old, the older; SMALL ENTRANCE FEE/MODERATE PRICED FOOD." There was even an amateur flower show "aimed at stimulating interest in better gardening." All flowers had to have been grown in home gardens by the exhibitor.

The brochure also offered a wonderful history of Mandarin. There was mention of the Louis Tiffany stained-glass windows, dedicated to Harriet Beecher Stowe, in the "attractive old Episcopal Church on the St. Johns River." It also mentioned other parts of Mandarin: the "live-wire Community Club, Fire Department, Blood Bank, Well Baby Clinic, Home Demonstration Class, Library, Garden Club, Mandarin Players and Athletic Club, which owns one of Florida's finest baseball diamonds and supports a winning ball team." Proceeds for the event were to be used to beautify the community club grounds.

When I recently stopped by the present-day Mandarin Garden Club to return old scrapbooks, I was struck by a familiar genteel quality shown by women celebrating their end-of-the-year luncheon. Of course, these women did not wear their strands of pearls or white gloves, nor were they outside in the heat. Instead, they sat in their cheerful clubhouse in the air conditioning and wore sporty outfits along with happy faces. Seeing them enjoying the moment made me admire all women who have ever worked together to make something of value happen, and it made me think of my mother and all the women before her.

After my column about the Mandarin Garden Club ran in the *Florida Times-Union*, my uncle Byron, who is eighty-eight and a retired TV producer, wrote me the sweetest note. It said:

A generation before your mother, housewives had at least one outlet: the bridge club luncheon. Your grandmother, for example, belonged to a bridge club of perhaps 25 women. The protocol was, each member had to be hostess at her house and the duty revolved among the members. I remember your grandmother working herself into a nervous state because her luncheon had to be the best of all. Of course, the other women felt the same way when their turn came around. As a result the cuisine rose to giddy heights of taste and presentation. I believe so many rubbers of bridge were played, then came the goodies, then more bridge with someone winning a prize (paid for by the hostess). What did they eat? I recall bread loaves with their crusts sliced off then cut lengthwise. Each layer was slathered with a different coating—pimento cheese, deviled ham, sliced cucumbers and whatever else. Then the loaf would be cut into sandwich sized slices. No! Forgot. Before final slicing the entire loaf with its different layers would be smothered in cream cheese or perhaps whipped cream. One dessert was an English trifle: layers of crumbled lady fingers, cherries, whipped cream, and nuts. You see how the mention of garden parties set off in me, like Proust's Madeleine, Remembrances of Things Past.
Love, Byron

We in Jacksonville had another very powerful feminine influence who was part of our daily lives for as long as I was a child and even into my young motherhood. Virginia Atter Keys was that feminine paragon. When I was able to set up an interview with her, I admit I was a little star-struck. I was actually nervous to be sitting at the dining table of Virginia Atter Keys on a beautiful Neptune Beach morning; this Jacksonville television and radio icon of the '50s through the '80s was an ever-present force in the media when I was young.

And when she sang for me her favorite song, "The Man I Love," with her rich, torch-singer voice, I almost wept. "That was the song I sang on *The Arthur Godfrey Talent Scouts*," she told me when she had finished singing. "And I won."

How could she have lost? Even though she retired in the '80s, her voice was as pure as ever, and as I listened to her, I took a "sentimental journey" to an earlier time in my life.

Virginia Atter, young singer.
Courtesy of Virginia Atter Keys.

Virginia Atter was the oldest of four girls and three boys of a first-generation Lebanese family. She was born in Massachusetts, but her family soon moved to Jacksonville. Today, all of her sisters live near her in the Beaches area.

Keys, a deeply religious woman, had her first Communion at downtown's Immaculate Conception Catholic Church, where she and her family worshiped and where she attended school. At an early age, she was certain she was going to be a nun, but her destiny would follow a different path.

When she was in high school, she won a number of local talent shows sponsored by Foremost Dairy. Then, the Roosevelt Hotel manager asked her to sing at his hotel. "I told him I couldn't possibly do that because I had school. And he said I could sing during the happy hour, 4:00 to 6:00 p.m., and still keep up with my studies. He did worry about my being safe walking home. We lived on Duval Street, and I had to walk. So he hired a woman to take me home."

At the end of 1949, when WJXT TV-4 was still WMBR, Keys quickly found her niche in television. She was hired to host talk shows and do

commercials. Soon, she was joined by Dick Stratton, and they co-anchored for more than twenty years, interviewing guests and newsmakers, with breaks in between to present commercials or "a word from our sponsor."

"We were in black-and-white in those days," she said, "and we would come in early and begin just talking. We didn't need much makeup until they had color. They'd give us news stories to read and commercials to do, but mostly we were on our own to make things happen."

Keys said Stratton was a sportsman and a very dear man who introduced her to her husband, Jim. "He fell into the job of anchor so gracefully," she said, "and he never was the 'star of the show.' He was generous with his celebrity. When he became a WJXT sportscaster, he went to all the games he could. It was a sad day in 2005 when he passed. I still put flowers on his grave."

Keys also had a fifteen-minute singing show every night in the early days of TV. Along with her was a band consisting of Tommy Wood, Tommy Carroll and Larry Hartsfield; sometimes these musicians would sing harmonies with her.

Her TV job also afforded her many wonderful opportunities to meet and interview famous people. One of her all-time favorites was Danny Thomas of *Make Room for Daddy* fame. "He asked me to serve as emcee on one of his St. Jude Children's Hospital shows. I'm sure that we connected because of our Lebanese heritage, and he was so excited that I knew how to speak the old language—Arabic—and I could sing the old songs in Arabic, too. We kept in touch for many years and became really good friends."

She also interviewed her share of local celebrities. One guest was Archie Eason, designer of very popular women's hats at Cohen Brothers Department Store across from Hemming Park. In one show, Keys modeled a huge assortment of hats.

She eventually made a move to WFGA, which became WTLV TV-12 in 1972. Here she hosted a show called *Today in Jacksonville*. "We've all worked for the various stations. We in television were like a big family."

When the interview was drawing to a close and I had finished asking my questions, she made sure I'd call again. We'd go to lunch, her treat, at an Arabic restaurant, and I would bring my granddaughter so Virginia

Right: Virginia Atter Keys and Danny Thomas. *Courtesy of Virginia Atter Keys*.

Below: Virginia Atter Keys with Archie Eason, Cohen Brothers hat maker. *Courtesy of Virginia Atter Keys*.

could hear her sing. And maybe she'd bring her sisters, and we wouldn't have to worry about interview stuff. I assured her that I would love that. We parted best friends, just as we had always done at the end of each of her shows. It was a wonderful morning, indeed.

As I was preparing this piece for the book, several people shared their insights with me on Virginia Atter Keys. Connie Lahey Rennie, sixty-one, a retired English teacher, said:

> Remember this? "Rid-a-Bug, Rid-a-Bug. There's nothing greater. No more Mister Exterminator. Just spray it here, and here, and here, and here. No more bugs for half a year!" One of her [Virginia's] commercials. Don't know why it stuck with me.
>
> Also, the best renditions I have ever heard of "Ave Maria" were Aaron Neville's and hers. Unbelievable. Don't know where I heard her sing it—probably Immaculate Conception—but it was riveting.

Mary Jo Trenkler, retired television employee, said, "I have had the wonderful opportunity to sit and chat with Virginia several times over recent months. You do feel like you are best friends. She shares her pictures and stories with such delight. She's always having fun. And couldn't the world use a lot more people like her?"

I suppose that whether they realize it or not, television and radio personalities really do impact the lives of people in ways they could never begin to comprehend—for good or bad. But all of us can assure Virginia Atter Keys that her elegant, distinctly feminine impact was so positive. All of our lives have been made richer for having tuned in to her shows.

Schoolboy Patrols

No Girls Allowed

I distinctly remember a provocative recruiting poster of many years past. It wasn't as famous as the one with Uncle Sam pointing his imposing index finger and saying "I want YOU!" The one I remember was of an attractive young girl dressed in a navy uniform saying, "GEE!! I WISH I WERE A MAN. I'd JOIN the Navy!"

I could really relate to the concept promoted in this poster. Not that I would have signed up in the navy, as my father had during World War II, but because the poster captured the kind of longing I had when I couldn't be part of the Schoolboy Patrol during my elementary school years.

Oh, how wonderful it would have been to get to snap that traffic flag as I would usher small children to their waiting educational experiences, all while wearing sashes and a dazzling white uniform and helmet. But in 1960, when I was the same age as the boys who got to be in the patrol, I had to be in the background. In Jacksonville, girls were not allowed to be part of the patrols.

According to Leticia Messam, public relations contact of AAA (American Automotive Association), the School Safety Patrol was started in the 1920s by the Chicago chapter of the organization. From there, it spread to other chapters in order to promote safety in and around automobiles. Messam was, however, unaware that girls of earlier

generations were not allowed, saying that each chapter got to set its own rules and that must have been one of the rules of AAA's Auto Club South.

Unlike me, Raymond H. King Jr., seventy-six, got to be part of the Safety Patrol experience. King is a retired chemical engineer who worked for thirty-nine years at Eastman Chemical, and he has written several histories about the Riverside area. He remembers well what it was to be a member of the Schoolboy Patrol, as he was one at Fishweir Elementary in 1946. He said, "I often wondered why I was chosen to be on the patrol except that maybe someone just wanted to see me stand in traffic for twenty hours a week."

More seriously, however, he spoke of his responsibilities:

We would man school crossings, two in front of the school, a crossing near where Hershel and St. Johns split, a crossing at Fairfax and I think there was another crossing behind the school. We were at our stations in the morning, at lunch, at two o'clock when the lower classes were dismissed and at three o'clock when the upper classes were let out.

All the kids either walked or rode bicycles. Nobody came in a car. The only cars were in the faculty parking lot, but mostly there were many bike racks with many bikes.

Another person who remembers distinctly the joys and rigors of being a patrol boy was John Dykers Jr., currently of Siler City, North Carolina. The seventy-six-year old retired doctor said:

My patrol station was at West Riverside, 1945 and '46, I think. So much was disrupted by World War II that I was in a distant school for the last of second grade, third grade and the first part of fourth. But I remember Mrs. Hughes, the principal, and Mrs. Hope in first grade. I think I had Mrs. Richardson in second and definitely Mrs. Cooper in fourth, Mrs. Davis in fifth and Mrs. Cash in sixth. I remember that was the year we went to Cuba, to Havana, as the Schoolboy Patrol Reward Trip. There were flying fish off the bow of the ship between Miami and Havana! We had great pillow fights in the hotel in Havana!! And there was our time at Morro Castle! There was the bus ride down to Miami

and then the ride home. What wonderful memories of having gone and
of the excitement anticipating going.

Kings Trail Elementary School (the name South San Jose Elementary
was given during the Bicentennial), where I was a student, has preserved
several scrapbooks from my days there. In one scrapbook marked 1957–
1960, many wonderful photographs and bulletins captured the events
of that simpler time—from fall carnivals to fashion shows for the PTA
mothers and daughters to patrol boys marching in formation.

Jack Overfield, sixty-one, a retired FAA Air Traffic controller, was one
of the boys of my school's patrol when I was there. He said:

Danny Storch was our captain. Tommy Boydston was lieutenant, and
Herb Cochley was sergeant. There was a patrol boy room where our
helmets, patrol belts, crossing poles and rain gear were stored.

Patrol boys at South San Jose in 1961–62. *From left*: Martin Berman, Chip Hauge, Jim
Farley, Bobby Keegan, Mike McManus, Trippy Shave, Buz Purser, Charles Rogers,
Jack Overfield, Burt Kelly, Tommy Boydston and Herb Cochley. *Courtesy of Kings Trail
Elementary School.*

When rain threatened, we wore yellow raincoats, yellow rain hats and boots. Otherwise, we wore yellow helmets and silver badges on green shoulder and waist belts. Only our faces beamed brighter than our badges. There was a feeling of pride in guarding a street corner with a crossing pole and helping fellow students safely cross. I felt extra proud when my two younger sisters came to my crossing.

There was one item in all the memorabilia at my old school that spoke to the importance of the role the patrol boy served. It was a mimeographed page containing the Schoolboy Patrol oath. It reads as follows:

I promise to do my best to:
Report for my duty on time.
Perform my duties faithfully.
Strive to prevent accidents, always setting a good example myself.
Obey my teachers and officers of the patrol.
Report dangerous practices of students.
Strive to earn the respect of fellow students.

Patrol boys at South San Jose in a parade drill, circa 1961–62. *Courtesy of Kings Trail Elementary School.*

I must say, the boys who were my classmates certainly earned my respect. In their dress whites, with colorful badge sashes and white hardhat helmets, these young men really did provide striking images of "men in uniform" that we girls shamelessly adored.

It was just that in my case, I secretly yearned to be the type everyone admired. This was, however, to be for other girls several years down the road. Instead, I got to be a librarian's helper. Shelving books was all the pageantry I was going to get to enjoy.

Pastimes of Past Times

Music, Putt-Putt and Princess Phones

Sometimes I can tell I am getting older, especially when I hear myself say, "What's with all these kids these days texting on their cell phones?" When I really think about it, though, kids today aren't all that different from kids of the '50s and '60s. When I was a teenager, my parents were constantly harping about how I tied up the family phone talking to my friends.

Oddly enough, it was my parents who arranged for me to get my own phone when I was in sixth grade. Imagine my joy when on Christmas morning, I opened a thin box with the paperwork for the installation of my very own princess phone in my very own bedroom!

In the *1961 Southern Bell Telephone Directory*, advertisements for the princess phone said, "It's little. It's lovely. It lights." I remember marveling at how beautiful my new phone was. It matched perfectly the baby blue color of my walls, and it sat on my desk where I did my homework. The rotary dial lit up when I picked up the earpiece, and when anyone called, there was a delicate ring compared to the clanging sound of the old black rotary phone we had back in East St. Louis.

Sadly, not long after it was installed, my boyfriend caller moved on to another girlfriend, leaving me quite sad, and my princess phone was quite silent. It collected some dust and a few cobwebs, but then I fell in love with someone else and all was right with the world again.

A '50s and '60s River City Childhood

Former Jacksonville resident Dottie Stone Taylor, who worked for the Early Learning Coalition of Florida's Gateway Inc. near Lake City, remembers her family's princess phone. "It sat proudly in a niche in our hallway on a gossip bench, and my brother and I fought over who got to use the phone all the time," the sixty-three-year-old said. "The only other problem with this phone was it wasn't very private. You had to be careful what you said since the family could overhear your conversations."

Things changed when her father had a second heart attack. Taylor said, "My father's company footed the bill for a second phone to go on the nightstand next to his bed. I had many dreamy conversations with boyfriends on that bedroom phone, and they were actually pretty lame conversations. You could hear me sighing all the time and answering many questions with single words. 'You going to Y-Teens tonight?' 'Yes.' or 'You get the answer to number 47 yet?' 'No.'"

Phone use certainly has changed since that time. Phone numbers back then contained a letter portion or an exchange. Jacksonville had five exchanges listed in the 1961 phone book: Elgin (EL), Evergreen (EV), Exbrook (EX), Flanders (FL) and Poplar (PO).

My old number was Exbrook 8-6528. I had to look it up, since I couldn't remember it. Seeing it on the page, though, made me feel a strange sense of déjà vu. I could almost remember what it felt like to be a little girl again and living in the house of my parents. By 1962, my phone number would change to all numerals.

Another thing that came back to me was that operators were necessary to complete local calls in the early '50s. Even into the late '60s, long-distance phone calls often were completed with their help. They helped us make two types of long-distance calls: station-to-station or person-to-person. The first charged the caller as soon as the receiving phone was picked up. The second, which was more expensive, had no charge unless the requested person could be reached.

Mandarin resident Claire Fleming King, a retired AT&T employee, started her career at the phone company as an overseas operator in 1968. "It was an exciting job, but they ran a tight ship," the sixty-two-year-old said. "I was told I got the job mostly because I had perfect attendance in high school. They even sent two women over to interview

my father to be sure that he would get me to work on time every day since I didn't have a car yet."

King also said, "Operators were always women. Men were told they need not apply since their fingers were too big to correctly push all the small buttons and their legs were too long to fit under the consoles where we were to sit."

King also had a princess phone just like I did. She got hers from the company for good attendance.

The marvels of technology have been wowing us for many decades. Still, I think that whispering sweet nothings into a princess phone has got to be better than texting them on a cell phone. But then, I am getting older.

Our music was another important aspect of our growing up. Certainly, the '50s and '60s provided teenagers of those years with plenty of memorable songs. I remember vividly that sometime in 1961, I bought my first 45 rpm records with my very own money. Along with the little plastic "thingy" I needed to put in the center so that I could play it on a turntable, I bought "My Boomerang Won't Come Back" by Charlie Drake and "The Lion Sleeps Tonight" by the Tokens. The first record I bought because it made me laugh and the second because it was the most beautiful song I had ever heard.

I also remember this purchase taking place in a Lakewood storefront called Hoyt's High Fidelity. Hoyt's was a family-owned business with two shops in the Jacksonville area at that time—one in Roosevelt Mall and the other in Lakewood. They specialized in custom-built stereos, component parts and records. Presently, there is a Hoyt's Stereo on Beach Boulevard near the Intracoastal Waterway that still specializes in sound systems.

In a *Florida Times-Union* article dated November 16, 1965, Landon Hoyt, one of four co-owners of the company, said, "Everything sold at Hoyt's is in connection with listening, from the very basics such as records to the more sophisticated sound systems."

Hoyt also said his stores had the largest selection of phonograph records in the area, and they were equipped to do special orders of any record not in stock. They were very much into this new concept called stereo. "A good bit of our efforts have been to carry a complete line of

components for stereo systems with the more discriminating listener in mind," he said.

That "discriminating listener" was my dad. His budget was limited, but he knew he could follow directions. So he went to Lakewood Hoyt's and bought a kit to build a sound system. I can still visualize him sitting at our dining room table with soldering gun in hand, the acrid scent of something burning filling the dining room. I can also imagine him out in the carport, sawing and hammering a beautiful cabinet to cradle his "creation." The sound system became the focal point of our living room and the center of my musical life.

Of course, one cannot mention Jacksonville record stores without including Abe Livert, a store that frequently ran ads on all our radio stations. According to San Marco resident Bill Binkley, the sixty-year-old stepson of Abe Livert, his stepfather got his start in music by forming a band in the '30s known as the Abe Livert Orchestra. "His was the first band to play at the San Jose Country Club," Binkley said. "He was the drummer, and my mother played piano."

Binkley's stepfather went on to build quite an empire of record stores, the first of which was in the Gateway Shopping Center. Binkley said that on Saturdays, big names would play there—Bo Diddley, Dennis Yost and the Classics Four, Bobby Goldsboro and even Slim Whitman, to name a few. Other Abe Livert Record Stores blossomed all over Jacksonville. Binkley said there were stores in Philips Mall, Town and Country Shopping Center, downtown, San Marco, Lakewood Shopping Center and, eventually, Five Points.

In 1994, Binkley closed the last of the Abe Livert Record Stores, and now, along with owning a music and pawnshop in St. Augustine—King Music and Pawn—he runs a mail-order music business.

Whether one needed a magnificent sound system or just wanted to keep up with the latest musical trends, both Hoyt's High Fidelity and Abe Livert Records provided hours of musical enjoyment for many people in Jacksonville. And I can't hear "The Lion Sleeps Tonight" without going back to a memory where I am wearing my bouffant hairdo, my Villager A-line dress and a pair of Weejuns while I searched through bins and bins of the latest records.

Of course, no Jacksonville adolescence was complete without having played putt-putt or goony golf at least once. Before the World Golf Village, the TPC (The Players Championship) and before fans mobilized Arnie's Army or were inspired to follow Jack Nicklaus, the youth of Jacksonville were spending many hours trying to hit yellow golf balls into little tin cups on interesting putting greens.

Back then, numerous miniature golf courses provided great places for teens to spend time with family and friends. Besides the drive-in movies, movie theaters, skating rinks and dances, kids found that miniature golf courses were certainly an excellent, semi-athletic way to be with people whose company they enjoyed.

I remember two places on Beach Boulevard especially well: the Putt-Putt Golf Course and the Goony Golf Course. Even though miniature golf courses still thrive—at Mandarin Mills and at the Adventure Landing complexes, for example—the little putting golf courses of long ago have a way of coming to mind at the oddest times. It is especially true when turning at the corner of Parental Home Road at Beach, where the old Robert Hall's Clothing Store used to stand. Just a few blocks east are the spots of countless fun-filled evenings.

I am not sure why I saved my putt-putt score card from 1965, but it certainly made me smile when I came across it while tidying my home office. My score on the card was atrocious, a full ten strokes behind that of my boyfriend. Holes No. 2, No. 9 and No. 10 proved the most difficult, since my score soared way above par in those squares.

Putt-putt score card, 1966. *Photo by the author.*

Still, I remember having "a blast," as we said in those days. It was really nice being enveloped in the instructive arms of my boyfriend as he demonstrated certain putting maneuvers I obviously needed to learn. His English Leather cologne smelled particularly dreamy, and his clean-shaven cheek next to mine was quite a delight.

Southside resident Hal Kelly, sixty-two, owner of Indoor Comfort and a weekend golfer, also remembers a few of those putt-putt evenings.

"Putt-putt was a good date night place to go. And we often took out-of-town company there. I also remember the little windmill. You had to carefully time your putt so the ball would make it through the blades to the hole on the other side. That hole was really hard."

Farther down Beach Boulevard was a Goony Golf Course, and it certainly lived up to its name. The most memorable part of that complex was an orange tyrannosaurus rex holding a huge bone in one of his claws. This he lifted and dropped methodically, allowing the balls to go through a tube to the hole. He dominated over a menagerie of fanciful creations, including Humpty-Dumpty and the Old Woman's Shoe, and he is the only character left to posterity.

Thankfully, in 2007, the University of North Florida's Department of Building Construction Management renovated this lone statue. The dinosaur now stands his ground in a shopping complex that replaced the old golf course. Even now, when I see the beast towering above the cars, I relive an evening there with friends as we celebrated someone's

Restored Goony Golf's tyrannosaurus rex next to Beach Boulevard. *Photo by the author.*

birthday. While we laughed and giggled at the many holes we overshot, we could hear the roar of a nearby go-kart track adjacent to the green felt putting surfaces.

One thing comforts me in all of this. Miniature golf, as well as regulation golf, is still well represented across north Florida. Any time I feel the need, I can putt around all I want, but I am in a very different place in my life now. I can't help but feel a bit of a tug at my heart when I cruise by those now-replaced teenaged haunts and recall those simple, uncomplicated evenings of adolescent fun. And I sometimes wish I could have just one more chance to get the ball past that old T rex or enjoy just one more special golf lesson.

When Christmas Came Too Early

I don't suppose I am alone in this, but I must have spent countless hours listening to the advice my parents offered me. My mother, in particular, offered many pieces of advice about living the good life whenever she saw fit to enlighten me. She always said that it was important to wear clean, non-raggedy underclothes, just in case I was ever in an accident. Another gem was that I needed to eat my vegetables or else I'd contract something bad, like rickets or scurvy. And, very importantly, never ever begin celebrating Christmas until after the Thanksgiving dishes were washed and put back into the cupboards.

Because of the way she said the last maxim, I was certain I needed to comply or the earth might stop spinning if I didn't. Just imagine, then, how she reacted when the Jacksonville city fathers had the Christmas holiday decorations put up on the lampposts during the August heat of 1959.

In a *Florida Times-Union* news article dated August 11, 1959, Leo Jansen, the chairman of promotions and development of the Downtown Council, arranged for several decorations manufacturers to display their products at 502 Hogan Street. The article was accompanied by a photograph of a workman on a large ladder as he put concentric tinsel circles with a star in the center onto a streetlight. The man was in shirtsleeves, and palm trees seemed to sway in the hot summer sultriness behind him.

The council was preparing to spend $17,500 on decorations for the Jacksonville downtown area "to brighten the streets for the holidays." You would think that extravagance alone would have gotten my mother's dander up, but she was more enraged that they had begun to prepare for Christmas months before it was "appropriate."

Of course, just remembering this old piece of news made me think of all the countless other types of decorating we children of earlier generations were able to enjoy during the holidays. Kuhn Flowers was, and still is, a decorating giant, with its huge front window dazzling with Christmas wonders at 3802 Beach Boulevard. Furthermore, lavish decorations at its St. Augustine and Ponte Vedra stores are quite the Christmas treat.

According to Harry Graham, seventy and the present owner of Kuhn Flowers, the major Christmas window display didn't begin until 1976. Before then, all the way back into the '40s, Kuhn's had the Christmas House next door to its Beach Boulevard locale, where Nancy Kuhn would decorate as many as twelve themed Christmas trees.

Kuhn Flowers Christmas window, a Jacksonville Christmas tradition. *Photo by the author.*

Downtown would be decked out with tinseled streetlights, the ones the city fathers wanted to replace. All the downtown department stores would dazzle as well—Ivey's, Furchgott's and Cohen's. Each did its part to make the time festive. They filled their windows with snowflakes and colorful shiny ornaments along with merchandise, and Cohen's had one window dedicated to showing every desirable toy any child could want. If memory serves, it even constructed an elaborate North Pole area on the mezzanine, complete with Santa and elves.

Mike Johnson, sixty-two, a songwriter, musician and retired metal shop teacher, recalls the wonders of these sorts of Christmas decorations:

> *Yes, my parents and I made special pilgrimages to the Cohen's store display windows that did have animated figures, toys, running electric trains, dangling airplanes, lots of spun-glass winter-looking fluff and fake snow. Spray snow was kind of new and, for us, exotic at that time. I had to have some and, finally, cajoled enough to get a can. Some of it is probably still stuck to the windows on the old house on Redwood Avenue.*
>
> *We also would ride around at night and look at the yard decorations of the rich people who lived on the river in San Marco. It should be noted that, unlike today, we were not doing these things immediately after Halloween and not all that soon after Thanksgiving either.*

So is it any wonder that every time *A Christmas Story* runs during the holiday—that TV special based on the short stories and anecdotes of Jean Shepherd—I find myself, just like Ralphie, gazing dreamily into a Christmas window memory?

I can just imagine all kinds of toys and wonders that a child of the '50s would have begged of Santa. Still, somewhere in the back of my mind, I can hear my mother's didactic side going into overdrive as the city went about its business. I will never forget my mother's consternation about the one hot, humid August when Christmas came much too early.

The Impact of the Bible Belt

When I look back on a Jacksonville childhood, one that spanned the '50s and '60s, I couldn't ignore one very powerful influence in all of our lives—religion. Not only did a person belong to his or her immediate family, but he or she also belonged to a church family; at least that was what it seemed like to me. Many of my friends attended private religious schools like Assumption or Bishop Kenny. Others in public schools attended Hebrew schools or catechism classes after school at least once a week. All of my friends attended worship services. They went either to synagogues on Friday nights or Saturday mornings, to Mass at Catholic churches or to services at any of many Protestant churches on Sundays. Best of all, most houses of worship in the area included vibrant youth programs, and I certainly thrived as part of one.

Jacksonville's religious tradition goes all the way back to the beginnings of our north Florida history. According to the book *Fort Caroline and Its Leader*, written by the late congressman Charles E. Bennett, this religious tradition began when Jean Ribault found the mouth of the St. Johns River on May 1, 1562; Charles Laudonniere was his second in command. Ribault named the water River of May and erected a marker on the south bank of the river so that he and others might return and set up a colony later.

It took a while longer for them to try to establish a permanent colony. Under the command of Laudonniere, three hundred people arrived at the mouth of the River of May on June 24, 1564. Most of these people were Huguenots, or French Calvinists, seeking religious freedom, but sadly, their efforts to establish a permanent colony here failed. Most were slaughtered by the Spanish in 1565.

These Huguenots came from the congregational/reformed tradition, as do Presbyterians, so I feel a sort of kinship to these lost souls, since I was and am Presbyterian. When we arrived in Jacksonville in 1957, my family found that establishing a home here was not nearly so difficult for us as it had been for the early Huguenots. We had the freedom to join a beautiful church called Riverside Presbyterian. Dr. Albert Kissling was the senior pastor, and to my little girl sensibilities, he was an imposing figure when speaking from the pulpit. We didn't stay members there very long because we moved to Southside, where we joined the nearby Lakewood Presbyterian Church (LPC) on Longwood Road (now called University Boulevard). I was eight then, and LPC was only six years old itself.

In 2010, when the sanctuary of my church turned fifty years old, I began collecting stories to prepare a history about the sanctuary and the members who built it. Before I began looking at my own church's history, I took a look at the history of many other congregations in Jacksonville. I discovered that all houses of worship have wonderful stories to tell. In 1901, the Great Jacksonville Fire reduced the city to a huge ash heap. Only one wall of the Immaculate Conception Catholic Church was left standing. In that wall near the top was a statue of the Virgin Mary. It was salvaged and is the only part of the original church that is part of the present-day building downtown.

In the 1940s, the Reformed Jewish Synagogue was badly burned. The congregation was invited to have its Friday night and Saturday morning services in the basement of the Cohen Brothers Department Store, now Jacksonville City Hall. The faithful worshipped in the Bargain Basement for over a year until their synagogue was repaired.

The building where San Jose Episcopal Church now stands was an administrative building and casino for the brand-new San Jose Hotel

complex built between 1925 and 1929. The whole development, called San Jose Estates, went bankrupt during the Great Depression and lay in a "slumbering condition," according to a *Florida Times-Union* feature article written September 29, 1974.

The hotel building was reopened as the Bolles Military Academy in 1933. The golf course and swimming pool of the hotel complex continued as a semiprivate organization. On October 22, 1947, the first official meeting of the San Jose Country Club was held, and it eventually became the beautiful country club that it is today.

The remaining property of the hotel complex would become an Episcopal church. On September 28, 1941, twelve families held a church service in what had been the hotel's administration building. Mrs. Afred I. duPont, the benefactor, allowed these families the use of the property since it would also serve as a chapel for the Bolles Military Academy.

In 1949, the gas station, casino and administration building were eventually deeded to the Episcopal Diocese of Florida, and Grace Chapel applied to become a parish in the same year. In 1971, the name was changed from Grace Chapel Parish to San Jose Episcopal Church, thus keeping appropriate the decorative shields on the building saying SJE—San Jose Estates to San Jose Episcopal.

After I was inspired by the stories of other houses of worship, I became inspired by my church's story. I browsed through old documents and photographs of my church, and I was immediately flooded with significant reminders of things past.

In 1957, four years after the first services of worship were held in the living rooms and garages of three adjacent houses on Duke Road in the Lakewood subdivision, the session of Lakewood Presbyterian Church began preparing for a new and bigger sanctuary. Their statement reads as follows: "The building of a House of Worship is an inspiring and challenging task. All of us understand that a Sanctuary is built to symbolize our faith in a Great and Sovereign God. It must therefore be a thing of beauty. It must be well-designed, and it must have the best construction possible. It must stand as a monument to our God. Nothing second-rate will suffice."

Once the elders, deacons and congregation committed to building a sanctuary, they hired Saxelbye and Powell as architects. Batson-

The groundbreaking ceremony for a new sanctuary for Lakewood Presbyterian Church, Reverend Charles Benz officiating, 1960. *Courtesy of Lakewood Presbyterian Church.*

Cook Company was hired as the general contractor, and there was a groundbreaking ceremony on May 1, 1960. Construction began soon after. Southern Desk Company and Mill End Rug House provided the interior furnishings for the church, and Gulf Life Insurance and the State Bank of Jacksonville held the mortgage. The building was finished a week ahead of schedule at a cost of $200,000.

The first worship service in the new sanctuary was led by Reverend Charles Benz, the first minister of the church, on December 25, 1960. Christmas fell on a Sunday that year.

John Bier, eighty-nine and one of the charter members of the church, said that his friend Don Leehouts, also a charter member of the church and owner of Mill End Rug Shop, was on his hands and knees installing the last of the carpeting the Saturday night before the first service was scheduled.

Peggy Benz Rawlins, eighty-eight and the widow of Reverend Benz, said that on the same night that Leehouts was laying carpet, her husband

was praying. Benz said prayers in every seat of every pew for every man, woman and child of the Lakewood Presbyterian congregation. It took him all night.

Rawlins also said, "Charles especially loved the clear windows of the new sanctuary since they allowed the trees to be visible, and they let in such beautiful light."

Reverend Benz was also profoundly impressed by the sanctuary's huge new cross. According to Bier, the first time Reverend Benz saw it, he was incredibly moved. The cross was lying in the aisle area as the carpenters were preparing to install it in the front of the sanctuary, a place where it has towered for over fifty years. Reverend Benz's words were, "Now, *that* is a man-hanging cross."

John Bier also recounted stories about how Reverend Benz found Bill and Tommy Christian and other little boys swinging from a tire swing they had made and suspended from the open rafters during the construction of the sanctuary. Thankfully, no one was ever hurt, that we know, and Bill Christian eventually grew up to be a Presbyterian minister.

Donna Fetter, a longtime member of LPC, told me about how the women of the church found little sandy footprints on the pew cushions one Saturday when they came to prepare the church for services on Sunday. She also mentioned a story that once, during one of Benz's sermons, two young girls crawled through the space above the nave of the church. They could actually hear the minister preaching. Now, the access to the crawl space has been padlocked tightly.

There is another story told in the church of the great doughnut robbery. One fall, for about three Sundays in a row, the Krispy Kreme doughnuts served during the Fellowship Time were not at the back door as they were supposed to be. Eventually, Benz came to church very early and waited in the steeple room, where he had a good vantage point of the door in question. He saw the culprit—a teenager from the congregation. In his sermon that morning, the minister mentioned what he had seen and what he knew. He said he would not go to the police if the unnamed person of interest came to see him before evening. Sometime later that day, a teen and his father came up to the church and made restitution for the stolen doughnuts.

The sanctuary has been, from its beginning, a most sacred place. Even before it was built, its space was already special. Scouts held their meetings there, and kids often played in the wooded area that would become a place of worship. As the young people of the church grew in their understanding, they wanted to become part of the community of faith. The twelve members of the first communicants' class were the first to be confirmed in the new sanctuary. Our class is the only one ever photographed. I am the girl on the far left with the frizzy Toni Permanent that my mother was famous for inflicting upon me on a monthly basis.

Although the sanctuary was there for us every Sunday for worship, it also served as a refuge when times were difficult. Many of us have been in the mourners' pew saying goodbye to friends and loved ones. The death of one of the youth, George Goodsir, in a horrific car crash on Parental Home Road was a devastating blow to everyone in this church. His pew,

Communicants' class of 1962 at Lakewood Presbyterian Church. *Front left*: John Ward, Jeff Herter, Greg Adams, Bill Owens and Buz Purser; *back left*: Dottie Ketchum, unnamed girl, Janice Gawley, unnamed girl, Pam Givens, Sally Martin and unnamed girl. *Courtesy of Lakewood Presbyterian Church.*

provided by the youth program of the church, is still in the sanctuary with a plaque bearing words memorializing him. The words are almost worn away by touching and polishing.

The Brides' Room was dedicated to the memory of Jeanice Townsend, another young person who died two weeks before her wedding. And many of us can remember being in this sanctuary the Friday after John F. Kennedy was assassinated. We and the entire country gathered for solemn services.

But our sanctuary is also a place of great happiness. Here, we have baptized our babies, watched children's pageants, taken our vows of confirmation, married our sweethearts, been commissioned to do God's work and made joyful noises in choirs and during services.

I wish those long-lost Huguenot souls might be able to know that their faith is strong and doing well in Jacksonville. I think they would be pleased to know that since they first stepped foot in 1564 on the south bank of the St. Johns River in Jacksonville, all faiths here have been able to thrive in the United States. The churches and synagogues of Jacksonville are more than places of worship; they play vibrant roles in the life of this community.

Things Delicious

Restaurants, Bakeries and More

Jacksonville had so many wonderful restaurants when I was growing up, and they were all over the city and all the way out to the beach. I cannot begin to cover them all, but there are some that all of us remember. There was Strickland's Town House and Patti's Italian and American Restaurant. And, of course, there was the classy Le Chateau. This place, which is now the site of condominiums at the beach, was so fancy that world-renowned celebrities went there whenever they came through town.

According to an article in the March 9, 1985 *Florida Times-Union*, "Betty Grable, Jane Russell, Victor Borge, Mamie Van Doren, Taylor Caldwell, David and Julie Eisenhower, Barry Goldwater and Prince Andrew" had all been guests at Le Chateau. In the article, the owner, Mrs. Johansen, said, "Liberace came here three years straight after performances in Jacksonville. Le Chateau used to be his favorite place to come. My father used to hold the place secretly open for him and after dinner he would go into the piano bar with my father and mother, and one night after midnight, Liberace and Betty Grable were in the dining room at the same time."

In 1963, there was another important Jacksonville restaurant. When people were still marveling over the wonders of a World's Fair, the

city of Seattle amazed us with the Space Needle. It was very modern-looking, and it had a revolving restaurant on top. It is, even now, one of Seattle's most enduring landmarks. I can't be certain that Seattle's accomplishment had anything to do with it, but about 1965, Jacksonville could also boast of its own revolving restaurant on top of the second-tallest building in the city at that time. The Embers Restaurant, as it was called, topped the Universal Marion Building, which is now home to the Jacksonville Electric Authority. The space that once was the restaurant is now a conference room, and it still has an excellent view of downtown Jacksonville. It does not, however, revolve anymore. Back in the '60s, though, we certainly felt elegant to have such a modern marvel in our city, and I felt very special when my father would take us to dinner there.

According to a postcard that is part of the Jacksonville Public Library's Florida Collection, The Embers Restaurant was the "world's largest revolving restaurant high atop the Universal Marion Building overlooking the city with a commanding view of the six bridges and the majestic St. Johns River." It served an American-Continental menu and a large selection of wines and cocktails.

A postcard picture of the interior of The Embers Restaurant, circa 1965–75. *Courtesy of the Jacksonville Public Library's Florida Collection.*

Southside resident Dana Austin, seventy-two and presently a front service clerk at Publix, knows a bit about The Embers Restaurant. His mother, Leona, who worked at such restaurants as The Lamp Post and the Seminole Hotel's restaurant, was a waitress at The Embers. "She started waiting tables back when coffee was a nickel a cup, but The Embers was a totally new concept, a revolving restaurant and a stationary bar," Austin said. "I think the last time I was there myself was at the ten-year reunion of Landon's class of 1956."

San Marco resident Kathy Boyd Quinn, a fifty-eight-year-old retired English teacher, said, "I remember The Embers Restaurant. I went there when I was an impressionable teenager, and let me tell you, I thought it very cool. It was very elegant and made for a great dressy night out. The restaurant revolved very slowly, and you could see the lights of the city sparkling on the river. It was wonderful."

Of course, there were a few things one had to consider when eating at The Embers. "You had to remember that where you started eating was not where you would end up," Quinn said. "You could also get disoriented if you went to the restroom. Your table was sure to be in a different place when you returned."

Madeleine Bronson and her husband were reminiscing about The Embers, and she said that afterward, "I called my daughters (who will be fifty this September), and they both remember The Embers with fond memories of an occasion. They recalled wearing their white gloves and carrying little velvet purses and their Sunday best dresses. They put their purses on the ledge, forgetting that the restaurant revolved and they had to go back and get them."

This was not an uncommon occurrence, apparently. Mandarin resident Claire Fleming said, "Sure, I went to The Embers Restaurant once or twice on dates, but one time, I left my purse on the window ledge and later when I looked up, it was gone," the sixty-two-year-old retired BellSouth employee said. "At first, I thought it had been stolen, but then I remembered the restaurant revolved. Thankfully, it wasn't long before my purse and I were reunited."

WAPE radio personality Jim Shirrah told me:

> *I met my first wife at The Embers in 1968. I lived in Jacksonville from 1967 to 1971 when I did the morning show on WAPE, the* Big Ape. *My roomie and me were having a drink at The Embers and spotted two bodacious females by themselves. We naturally asked the server to invite the ladies to join us for a toddy. They refused, so I took an Embers napkin and wrote, "Seriously, we'd just like to buy you a drink."*
>
> *I signed it "Jim Shirah WAPE Radio." Well, as luck would have it, my bride-to-be happened to be a big fan and listened every morning, so they came over. About a year and a half later, we tied the knot in my hometown of Daytona Beach. That relationship produced lots of memories and a handsome 6'4" Pinellas County sheriff's deputy (male). I still miss Jacksonville and remain in touch with lots of former WAPE DJs as well as listeners.*

There was something really special about getting all dolled up to have a night on the town. Places such as The Embers not only provided good food for us back in the day but also provided a space-aged elegance worthy of sophisticated cities that could host a World's Fair. Jacksonville could be proud of such a magnificent venue, and believe me, we were.

Memories of eating out certainly bring to mind other "sweet" eating memories—bakeries. When I was little, my family made weekly trips to the nearest shopping center, the Lakewood Shopping Center, a few miles from my house. Here, my family conducted all manner of business, from getting my brother his haircuts at Cliff's Barber Shop to buying food for the family at the A&P or the new Winn-Dixie. There was Lakewood Pharmacy, the Vogue Shoppe and Lester's Shoes, but it is Bowyer's Bakery that I remember most fondly. It was a place where the heavenly smells of cookies cooking or breads baking seeped from under the door to the sidewalk, and we little Ketchums would purposely wander past it. We would then stand in the doorway just so we could sniff the pleasurable aromas and dream of heavenly edible delights that our mother might buy for our dessert.

Of course, Bowyer's Bakery began as an institution many years prior to my childhood days. On a "50 Something" news segment that ran on

WJXT in July 1993, Dick Stratton interviewed Tom Bowyer, the owner of "our" wonderful bakery. By this time, Bowyer had been in the business for over forty-five years and had baked over 100,000 cakes. In 1948, he and his father, also Thomas Bowyer, opened a bakery on Sixteenth Street and Main.

In the interview, Tom Bowyer said, "Everything is made from scratch; no mixes are used for anything. Also, everything is weighed because it is a great deal more accurate that way. We even weigh the water."

When I spoke with Tom's daughter Cathy, now fifty-eight and a retired baker and restaurateur herself, there was obvious pride in her family's considerable contribution to Jacksonville's history. "There were three bakers in this area," she told me. "There was ours in Lakewood; Lazo's Bakery, one that specialized in candies that was almost at Emerson Street on Hendricks; and then there was Mims Bakery in San Marco, which had a little restaurant in it. We [Bowyer's] didn't have a restaurant until 1976, the same year my grandfather died, when we moved to the Winn-Dixie side of the Lakewood Shopping Center."

She went on to say that it was a very strange irony that all three bakers had daughters with diabetes. It was not easy forgoing the wonderful things for which their fathers were famous, but it was necessary. She did tell me that once a week she was allowed one cookie.

During the interview, Bowyer showed me a lovingly framed shadow box containing the formula book that her father had used throughout his career. It had loose-leaf, typed pages that were dusted with flour and stained by other baking ingredients. It opened to the page with icings.

She went on to say, "I had this framed and kept it in my own restaurant as a decoration. Daddy didn't mind that these were now to be publicly displayed. What he did like was being my cashier. He had sold the bakery in 1984 since he had begun to have heart troubles." Being cashier and depositing the money from lunchtime clientele at Bowyer's Restaurant in Riverside was just what he needed to stay active and healthy. He lived until 2001.

Mr. Bowyer was not only a great baker, but he was also a great employer. Many of my friends worked for him at one time or another. Even my brother Scott had after-school jobs there when he was old enough.

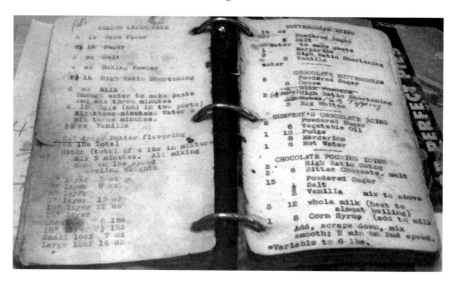

The recipe book of Mr. Bowyer, the owner of Bowyer's Bakery in Lakewood Shopping Center. *Photo by the author.*

Mr. Bowyer was also boss to Gail Grossman Baker, sixty-eight and director of Child's Play Preschool. She said:

> *I got my work permit when I was twelve, and for about four years I worked at Bowyer's Bakery. I worked from two to closing on school days and Saturdays, and I worked until closing on Sundays.*
>
> *My main job was behind the counter, folding boxes to a certain point so you could slip a pie or cake into it quickly. I also enjoyed getting to fill the jelly doughnuts with this amazing machine. A good friend worked with me in the summer, and we had such a good time.*

Of course, when one talks about Jacksonville-area bakeries, one has to mention Cinotti's at the beach. I went to see Mike Cinotti, fifty-five and owner and operator of Cinotti's Bakery and Sandwich Shop on Penman Road, and I was again overcome by the power of sweet baking aromas.

His bakery also has a long family tradition. His grandfather came over from Italy when he was fourteen at the end of the nineteenth century. Eventually, he settled in Ohio and opened a bakery in 1936. From there, the Cinotti bakery dynasty began.

Mike's father, Joe, and his uncle, Nick, helped the grandfather until he retired in 1955. When the grandfather and his wife vacationed in Florida, they fell in love with the climate, and soon after, the sons moved their families and the bakery to Jacksonville.

Their first shop was on Beach Boulevard near Patti's Restaurant. It even had a drive-through. In 1964, the family opened a second shop at 219 First Street, Jacksonville Beach. In 1965, Nicholas, the grandfather, died, and in 1966, the family sold the Beach Boulevard location. In 1970, the remaining bakery moved to 133 First Avenue, and in 1986, the family sold it. Eventually, Nick and Mike joined forces and opened Cinotti's Bakery and Sandwich Shop on Penman Road.

Mike literally grew up in the bakery business. He even met his future wife, Doodle, when she was hired by his uncle. His eighty-four-year-old father still works at the bakery two days a week for four hours a day.

When I asked Mike what's the best part of being a baker, he said, "It has to be family. No doubt about it. Dad worked for his dad, and

Cinotti's Bakery and Sandwich Shop on Penman Road at the Beach. *Photo by the author.*

I worked for mine. Now, I have seven grandchildren, some who are working here as well."

I could tell that this had to be a fun place to work. Good-natured laughing and chatting swirled around in the warm, sweet-smelling atmosphere as the staff filled boxes with cookies and iced gingerbread houses for the season.

My delectable journey would not be complete until I traveled to the Westside to interview Sandy Poletta, the present owner of the "fabled" Edgewood Bakery at the corner of Post and Edgewood Avenue. She is another Jacksonville baker whose life for the past twenty-one years has been all about the baking. Edgewood Bakery has been around since 1947, when it occupied a different space one parking lot away.

According to Poletta, the bakery was originally owned by the Brown family, who were connected with a grocer named Plimell's. Twenty-two years or so later, the Poppingas family bought the bakery. In 1980, the bakery was sold to Gary and Sandy Poletta. About six years ago, the bakery space was so limited at 1,700 square feet that when the building on the corner became available, the Polettas jumped at the chance to move to the 6,000-square-foot building.

Sandy says:

> One of the most important things that we have been able to do to survive this long is diversify. With the price of commodities rising so dramatically, we have had to do so much more than just bake. We offer a full lunch and breakfast in our café, and we have an upscale bistro that serves dinners on Thursdays, Fridays and Saturdays. We provide full catering in the hall we have on the property, and we can work off-site. We are also a full-service bakery, making everything from scratch. We can, in certain seasons, make as many as 3,500 cookies an hour.

Her bakery like all the others, is a family commitment. Both of her children work there. Gary Ray is the head baker, and Christy Ray serves as CFO. A third generation works there as well—Sandy's grandchildren help with special events and have summer jobs at Edgewood.

Edgewood Bakery at the corner of Post Street and Edgewood Avenue. *Photo by the author.*

When I asked her what she loved most about her job, she said, "The creativeness of it—I love being able to fulfill the vision of my customers as it concerns their tastes, how they want things to look and how successful their events go."

She also went on to say, "The one thing that inspires me and keeps us motivated is being a part of the lives of many people—whether it is just providing a pastry for them to enjoy or being a part of a celebration. I love being part of it. On a day before a major holiday like Thanksgiving, the bakery often serves over five hundred customers. That's a lot of lives we touch."

Of course, when I stepped out of Edgewood Bakery, I was struck by the importance of the corner at which I was standing—Post and Edgewood. Across the street and down one business stands Flowers by Pat. In 1924, the place opened as Small's Drug Store, Pat Cyrus, the present owner,

told me. She bought the place in 1983 to become her florist shop after it had been Jake's Apothecary for about ten years and a game room for about two. One of the most extraordinary things about this place is that Cyrus left the old soda fountain counter in place. She also left in place all sorts of drawers where Mr. Smalls, the original druggist, stored his supplies. Even the white hexagonal tiles are still on the floor, as they have been from the beginning. One can only guess at how many sodas, malts and milkshakes have been shared by young couples on the stools that are no longer there.

I could not leave this corner, however, without mentioning the Dreamette just up the street one block. The soft-serve ice cream shop has been a fixture in the Murray Hills area for years. According to Brad Nettles, twenty-six, the son of owner Johnny Nettles, the Dreamette at 3646 Post Street was opened in 1948 and has continuously offered soft-serve ice cream at the present location ever since. Vanilla, chocolate and its special hand-prepared strawberry ice cream have been all the rage for many years. Although there is a Dreamette in MacClenny now and there are plans for a Dreamette in Mandarin and Callahan, the Post Street location is still "tops," as they used to say.

"Probably the best part of working at the Dreamette," Nettles told me, "is watching the different generations come here. People bring their kids, then their grandkids and eventually their great-grandkids."

Luisa Lawrence-Reiser, fifty-four, director of sales at Homewood Suites by Hilton/Cambridge in Arlington, Massachusetts, said:

The Dreamette was a big hangout in the '50s, way before my time. Then, when I came to town in 1968, it was the place to get a soft-serve cone, dips of various flavors—chocolate, butterscotch, strawberry—they even had some killer shakes, and it still does! In 1968–69, I was a fan of the chocolate marshmallow shake, but now the coffee shake is number one for me.

Back in '68, it backed up to a convenience store. Kids from John Gorrie and Robert E. Lee hung out there, then went over to the Murray Hill Theater or the Murray Hill Branch of the library. When I go home to Jacksonville, no trip is complete without a trip to the Dreamette.

You must go there and sample their wares and see their sign behind the counter: "Hire an 18-year-old while they still know everything." That's a new sign, but hilariously true.

So many delicious memories filled my mind, especially after so many on-site interviews where many samples were provided. Whether it was a fancy restaurant like The Embers, or the weekly visit to the bakery like Cinotti's or Edgewood, or the summer afternoon walk to the Dreamette for a cool treat, Jacksonville kids have had many wonderful places to satisfy their palates or calm that sweet tooth. It is no wonder that watching our weight in Jacksonville can often be a hard thing to do—now or as when I used to stand in Bowyer's Bakery doorway taking in all the delightful aromas.

Train Station Memories from Grandpa to Ramses II

Trains play an iconic role in the American experience, and train stations signify the beginning and the end of that experience. It is the place where you meet loved ones coming to visit, and it is the sad place where you have to say goodbye. Jacksonville's Train Terminal, now our Prime F. Osborn III Convention Center, was just such a happy/sad place.

According to the brochure "The Jacksonville Terminal: Railroading in the Grand Manner," the first train terminal in Jacksonville was built by the Florida, Atlantic and Gulf Central Railroad in 1858–59. It was "little more than a covered platform with a waiting room and a blacksmith shop at one end."

In 1883, the "first decent train station" was constructed by the Savanna, Florida and Western Railroad when it joined the Florida Central to form a Union station. That construction was followed by the grander Flagler Depot in 1897, a Spanish Mission–style building, some of which remains today.

By 1912, when the station accommodated ninety-two trains a day, the call went out for a design for a new and bigger station. Kenneth Mackensie Mucheson, a New York City architect, won for his design, a scaled-down version of Penn Station in New York. This building, with its 180-foot façade and fourteen Doric columns, is the lovely sight you can still see as you drive down Bay or Water Streets.

A '50s and '60s River City Childhood

One of my earliest memories of Jacksonville's train station is of greeting my paternal grandfather there, his leather "grip" in hand and fedora on his gray head. We had been waiting for him on the platform, thrilling to all of the activity around us. There were the swooshes of steam coming from under the cars, the sound of shrill whistles, the chug-chug-chugging of cars moving up and down tracks and the distinct "All aboard!" of conductors. I also remember feeling small in the immense echo-y space of the main waiting room as we click-clacked across the marble floor, taking my grandfather out to our car. Then, I felt incredible sadness in that same room a few days later when we hugged and said our goodbyes, never knowing if there'd be another visit.

One of my happiest memories of the terminal was the gathering of Wolfson's senior class of 1968. In the waiting room, we congregated in preparation for our senior trip to New York City. We were irritatingly giddy, I am sure, as we collected our things and then moved out to the platform to board the train for a whole new world.

As I remembered it, the ceiling in the terminal waiting room was still vaulted, but Patrick Hinely, Wolfson class of '69 who also went on a New

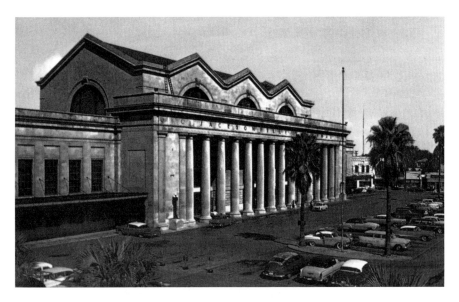

The Jacksonville Train Terminal, now the Prime F. Osborn III Convention Center, 1960. *Courtesy of the Florida State Photographic Archives.*

York senior trip, says otherwise. "My dad, James W. 'Bill' Hinely, was not only the Jacksonville passenger agent for the Seaboard Railroad, he was also a bit of a freelance travel agent, and in that capacity arranged and accompanied high school groups from all over north Florida to Washington and New York."

Hinely went on to say:

> *By 1968, a dropped ceiling had been in place in the waiting room for several years. This is another thing I remember well from repeated exposure, beginning at about age six, when, much to my mother's relief, Dad would sometimes take me with him to meet the trains at the station. As passenger agent, his job was to make sure everything was in order with passengers arriving and departing. Trains could leave whenever the conductor said it was OK, but they always signed off with my dad first. Standard procedure. Between trains, Dad would usually work at the Seaboard desk, one of four in the passenger agent's office located in the northwest corner of the main waiting room (to the left of the ticket windows), and I was given free run of the big waiting room. About the time I stopped accompanying Dad to the station—when I was in sixth or seventh grade—was when the ceiling got dropped.*

Oh well, so much for the accuracy of memory. In any event, the dropped ceiling is now gone from the Prime Osborn's main room. It has been restored to the glory of the former state that I had remembered.

Fran Spiwak Passero, sixty, who is now a retired federal government employee and lives in Mobile, Alabama, was a classmate with me on the trip to New York. She said:

> *My father worked on Bay Street, so we passed by the train station quite a lot, and we often went there to meet relatives who had come to visit us here in Florida. As a child I had never really gone on many vacations since my father owned his own business and was really too busy to take us anywhere. So this trip to New York was like a vacation for me. It was lovely, and there was so much to it.*

First, on the train ride, I remember that we went through all of this rolling green acreage, and I was so impressed. I had never been out of Florida, so I had never seen a hill. I also saw a real live hippie for the first time when we got to the Hotel Edison.

She said, "New York was so exciting. There were all the cultural things we got to do—the Guggenheim, the Metropolitan Art Museum, Broadway plays and the Rockettes. And there were automats!"

Less than ten years after our trip to the Big Apple, the last train passed out of the terminal on January 3, 1974, and it was more than a decade before a permanent transformation of the station took place. Finally, in 1986, the Prime F. Osborn III Convention Center opened.

That brings me to one of the best moments I recall of that hallowed space. My school-aged children and I were being guided by a docent down a dark, tunnel-like display. We moved through the claustrophobic tunnel, and suddenly we practically tumbled into a brightly lit chamber that held a massive stone statue of Horus, the Egyptian falcon god, wrapping protective wings around the pharaoh child, Ramses II.

There, in what once was the main waiting room of a train station that had witnessed the bustle of millions of train travelers—patrol boys and soldiers, grandparents and cousins, classmates and field trip buddies—was a world-class museum-quality exhibition that made me tremendously proud of my city. What a triumph for Jacksonville!

Our Better Angels

Hope Haven Children's Hospital, Dr. Morris A. Price and the Jacksonville Humane Society

There are certain times I would just as soon forget, especially in childhood—like when I broke my wrist playing line soccer in Miss Thomas's fifth-grade class or when the measles prevented me from trick-or-treating one year. Sometimes, however, children have more serious problems, and in earlier times in Jacksonville, there was one place that provided compassionate, long-term medical care for those kids who needed it—Hope Haven Children's Hospital.

The first time I ever heard of Hope Haven was when I was in the fifth grade and my best friend required three months of bed rest for rheumatic fever. Then, I heard of it again in 1965 when Edward J. White, now sixty, and his friend John Leupold were both injured in the same motorcycle accident. White, a retired banker and educator, broke his right femur and Leupold his left. Together they were at Hope Haven, first in traction and then body casts, for three and a half months. White recalls:

Hope Haven was a great place. That's because we had visiting teachers who did a wonderful job keeping us up with our studies. Our teacher was Mrs. Shirt, I think, and when we were finally able to go back to our regular school, we felt as if we were way ahead of the others in class.

A '50s and '60s River City Childhood

I do remember that on Thursday nights, they always served liver, and thankfully, John's mother would bring us barbeque from across the street on those nights. I also remember a wonderful old couple who came around frequently with a cart of arts and crafts projects for us to make.

Another person who knows all about Hope Haven is Wanda Hamm, fifty-eight, of Orange Park, Florida. When she was a child, she lived in Pierson, Florida. She said:

For five months, when I was ten years old, I went to Hope Haven, the only children's hospital in the area at the time. There was an older couple there. They were actually brother and sister. There was an article published once in the Times Union *about them and their dedication. There also was a therapist named Florence Mattox. I also remember a nurse named Ms. Anderson. I received a gift from her years later in life. When she passed away, she left a list of patients she wanted some of her personal items to go to. My doctor was John F. Lovejoy. His son is now a doctor in Jacksonville. I have many cherished memories about Hope Haven.*

According to promotional literature provided by Laurie Price, present-day executive director of Hope Haven Children's Clinic and Family Center, the hospital was originally founded in 1926 near the Trout River to serve malnourished children and those with tuberculosis. In 1940, Hope Haven moved to a new hospital facility on Atlantic Boulevard, where children with polio were treated. By the time polio was under control, over twenty thousand patients had passed through the hospital's doors.

In 1980, the facility began to limit itself to outpatient services, and in 1990, the facility was sold and moved to its present Beach Boulevard location. Here it serves as an outpatient facility for children with "educational, developmental, and mental health concerns." Apartments are now located where the old hospital once stood.

Pediatrician Dr. Richard D. Skinner Jr. is now ninety, and from 1951 until the Atlantic Boulevard facility was sold in the 1990s, he worked with

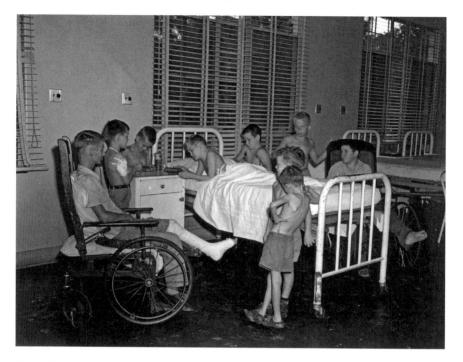

Boys at Hope Haven Children's Hospital, 1946. *Courtesy of the Florida State Photographic Archives.*

the patients at Hope Haven. He serves on the advisory board of today's Hope Haven. He is proud that the old facility provided patients with two academic classrooms, tutors and one shop class.

Skinner said:

> *We had a very stable staff without much turnover, but the visiting hours were very limited. Sunday and Wednesday night only. One of my best accomplishments at Hope Haven was getting the staff to institute more frequent visiting hours. The fear was that there would be a tremendous influx of visitors at all hours, but we found that when visiting was scattered throughout the day, it was actually much easier to manage.*

Not everyone may have firsthand knowledge of the benefits of the old Hope Haven, but those of earlier times who were treated there are

sure to feel great appreciation for this place that certainly lived up to the meaning of its name.

There were certainly many others who helped kids during their illnesses. When I was growing up, there were many wonderful pediatricians in town—Hugh and Cornelia Carithers, Walter Kelly, D.P. MacIntosh and James Lanier, just to name a few. There was one doctor, though, who touched my family in such extraordinary ways that he was not only our pediatrician, but he also became the pediatrician of my children and the children of my siblings.

Morris A. Price was born in St. Augustine in 1920, and he graduated from the University of Florida and Emory School of Medicine in 1944. After serving in the army in Korea from 1945 to 1947, he returned to intern at Duval County Hospital. He went back to Atlanta to complete his residency at Grady Hospital.

In 1949, he began his long career as a pediatrician in Jacksonville, and in 1956, he and Dr. John Ivey set up a practice together in San Marco across from Hendricks Avenue Elementary School. For over thirty years, Dr. Price worked tirelessly with the children of this city. After he retired in 1986, he even continued to work part time at the Health Department. He died in 2004.

Price was one of the most genuine and kind souls I have ever known. When I was a little girl, he always seemed to know what to do to fix things so that I was soon well and happy again.

Dr. Morris A. Price, one of many excellent pediatricians in the city of Jacksonville during the '50s through the '80s. *Courtesy of Donna Price.*

When I was grown, married and pregnant with my first child, Price invited me to his office to talk about prenatal and postnatal care for the upcoming generation. When my second child was born, Price showed up in my hospital room just to chat a while.

When times were financially tough for my husband and me, Dr. Price would let me run up a large balance for my children's medical visits to be paid off when I was in a better position to do so. Years later, when my father was diagnosed with Alzheimer's, Price called me on the phone to be certain that we had lined up the best possible care for my dad. I was extremely touched by his call.

On a morning not long ago, I had coffee with two of Price's three daughters. I told them of these many kindnesses of their father, and they assured me that this sort of behavior was second nature to him. His youngest daughter, Barbara Price McDonald, fifty-six and a licensed work artist, said:

> *My father lived how he believed; it was all about the patient. Whether rich or poor, sick or well, black or white, everyone mattered to him.*
>
> *Even at the end, when he got so sick and was really suffering himself, I used to take him for his treatments, and he'd have about a two-hour window of not feeling bad. We would drive around his old neighborhood, and he'd point out each house and which patient lived there. Me, I'd get lost, but he always knew how to go.*

Donna Price, sixty and a nurse practitioner, said, "My father cherished relationships. He could remember names and relatives and phone numbers."

He was also a very hardworking father. Donna said:

> *Even after Sunday school, we would go with him from synagogue* [Jacksonville Jewish Center] *to the old St. Luke's located at Eighth and Boulevard so he could do rounds there.*
>
> *My mother wouldn't let us leave the car to go play on the swings because the polio ward was nearby. Everyone was afraid of polio in those days.*

As both women talked lovingly of their father, they told me of Price's many hobbies. He did needlepoint where the back of each project was as neat as the front, and he collected baby bottles and left his vast collection to his girls at his death. He loved to write letters in his perfect longhand, and he had an impressive collection of illustrations by Maud Tousey Fangel, an illustrator from the '30s.

"At the very end of his life," Donna said, "he—as many people do—questioned his choice of career. Medicine was actually his fallback position. He wanted to be an engineer, but we were able to convince him, however, that he had made the right choice with his life."

Valerie Jordan White, fifty-five, a former patient of Dr. Price, had this to say about him:

> *My oldest son, Will, was so sick as an infant. He had to endure many painful shots. Dr. Price comforted him by calling him "Sweet William." When I was in college, I worked across the street at Brookwood Pharmacy, which did lots of business with Dr. Price. I can still see in my mind his handwriting on the RXs. It was very small, distinct cursive, and most of the time he had written Amoxicillin 500 mgm! He loved using small pharmacies like Brookwood that delivered because he knew that moms with sick kids were worn out after they left his office and all they wanted to do was go home.*

Mary Costello, eighty-four, is my former next-door neighbor, and she had a funny story about Dr. Price and her son, Leland. She said, "One day, Dr. Price finally had to tell Leland at sixteen that he just had to go to another doctor because he was too big to fit into those small examining rooms."

Retired pharmacist Herb Plotkin, seventy-seven, had a great deal more to say about Dr. Price:

> *My wife and I were privileged to know him, his wife Ruby, his children and grandchildren...I owned City Drugs on Thirtieth and Pearl Streets. That was one of the oldest stores in Duval County, and on occasion, Morris would stop by to examine the old Evenflo and Davol baby*

bottles. When I went out of business, I gave him the complete stock of such items that I had for his expanding collection.

City Drugs was one of perhaps two or three stores that remained open on Christmas Day for the purpose of allowing people to have their prescriptions filled. Morris and I would have an hourly dialogue updating each other on the medical traffic so as to make sure that a person with medical needs could be served. I well remember that I received a call from him in the early evening about a young patient that was coming to see him from St. Augustine and would I be available to fill a prescription for them. Needless to say, if Dr. Price asked anything of you, it would always be a pleasure to comply.

Plotkin continued by saying, "I recall that when one of my children was involved in a youth group, there were three out-of-city children staying at our house. One of the guests had an asthma problem and subsequent breathing problems at night. A call to Morris at his house resulted in him meeting us at Baptist Hospital, where this soft-spoken gentleman was there to do what he always did for his patients."

Bob E. Wolfson, sixty-three, is the nephew of Dr. Price, and he had this to say about his uncle:

Growing up in Jacksonville, it seemed Uncle Morris was always at our house applying his craft to either me or one of my four brothers. My favorite story is the one about his first office in Jacksonville (before he went into practice with Dr. Ivey). It was in a small medical building off San Marco Boulevard (somewhere around LaSalle). It came with two waiting rooms…one for whites and one for blacks. Uncle Morris would have none of that and made the small waiting room for blacks into a file room. If you wanted to see him (whether you were black, white or purple), you waited with everyone else. If you did not like it, it was fine with Uncle Morris if you went to another pediatrician. In the early 1950s, this was very radical, but it was how Uncle Morris lived his entire life. He was a man of principle, more than anyone else I have ever met. He lived those principles every day.

Finally, Peggy Mabry, RN, said:

> *I liked the way Dr. Price treated the parents of his patients. He didn't admit to the hospital every child that was sick. They had to be really sick. He always went out of his way to work with me trying to keep my son, Jason, out of the hospital. I really appreciated that fact. He also had an incredible memory. He amazed me that he could remember my son's friend Eddie, who was also a patient of his and would ask about him when he saw my son. He was a special man and doctor. I used to enjoy seeing him in the halls of the hospital after he had retired. He always had time to stop and talk for a minute. I also remember his baby bottle collection. He was ever the gentleman.*

Poet William Wordsworth once said, "The best portion of a good man's life is his little, nameless unremembered acts of kindness and love." And that is perhaps the best legacy left by Morris A. Price and the Jacksonville pediatricians of his generation—those countless unremembered acts of kindness and love as we children were helped and healed under their devoted care.

Another very important part of childhood had to be our relationship with our pets. There is no doubt that we kids in Jacksonville loved our animals, and we came by that love honestly. We were glued to the TV watching the magnificent collie Lassie, who saved Timmy and Jeff from all sorts of dangers. We watched *The Adventures of Rin Tin Tin*, a beautiful German shepherd that fought bad guys with the U.S. Cavalry in Arizona in the late 1800s. It is a small wonder that we begged for pets

Of course, Zsa Zsa wasn't exactly the crime-fighting, adventurous type of dog. She was my family's pedigreed miniature poodle that was rather high-maintenance. Still, we loved her, and she provided us with an incredible life lesson.

She had two very successful litters of poodle puppies, all of which we sold to good homes, but her third and final litter was a disaster. The only puppy was a stillbirth, and for days, our dog howled a strange little poodle howl that was absolutely heart-wrenching. When she crawled into a toy box and tried to mother a squeaky toy, we called the vet. He told us

to get another puppy, but that was easier said than done. We couldn't find a puppy in the neighborhood, in the want ads or at the animal shelter. Finally, we asked if a kitten might work, as the animal shelter had a litter of three-week-old kittens. The vet said it was worth a try.

My dad and I went to the local animal shelter, the Jacksonville Humane Society on Beach Boulevard, and adopted little Sadie, a calico kitten that became Zsa Zsa's favorite "puppy" ever. Within minutes of her arrival at home, the little cat was nursing heartily from her new mother, and Zsa Zsa became a completely healed soul. We were so grateful to the Jacksonville Humane Society, and I am sure we are not alone in believing it has long been an institution of compassion.

According to Pamela Javins, director of development at the Humane Society, the organization was originally called the Society for the Prevention of Cruelty to Animals (SPCA) and was founded in 1885.

"The present facility is on thirteen acres donated by the Bowden family, of Bowden Road fame, as a horse rest farm," Javins said. "As time went on, the Humane Society acquired more land so that we now have thirty acres.

"This facility is the oldest continuously operating humane society in Florida, and it is the second oldest nonprofit in Jacksonville. We are proud to say that in 2005, we became a 'no-kill' facility."

Sadly, many of us can remember when the Humane Society was badly damaged in a devastating fire in April 2007. The destroyed portion included the Annie M. Dore Building. According to a *Florida Times-Union* article on March 4, 1963, this building had been dedicated one day earlier in a ceremony with Mayor Haydon Burns in attendance.

During the 2007 fire, when firefighters released animals from kennels and cages, many animals ran into the woods. Some of the dogs, however, would not leave the firefighters. As a result, several dogs were adopted that very night. Lucky was one such dog, a lab mix that became the mascot of Fire Station 28, the first responder to the fire.

Because almost all of the historical data and photographs about the Humane Society were destroyed in the fire, finding certain factual documentation is impossible. But Leona Sheddan, the society's executive director, was able to confirm an interesting historical footnote I heard

long ago—the original humane society was the only place of shelter in Jacksonville for battered women and children at the turn of the twentieth century.

"What we are most proud of now is that despite the inadequate housing of the moment, the wonderful staff has been able to adopt out more animals than we did before the fire," Javins said. "And I love looking out the window and seeing families going home with their little bundles of energy in their arms or on leashes. It is great helping these animals find homes and knowing that we are enriching human lives as well."

Presently, the animal shelter is in temporary housing. According to Danya Parks-Freel, director of operations of the Jacksonville Humane Society, it will celebrate the grand opening of a full-service, state-of-the-art, low-cost community animal hospital on January 28, 2012. The Humane Society must still continue to raise funds for a new shelter for animals in need.

The gates of the Humane Society on Beach Boulevard. *Photo by the author.*

There can be no doubt that the Jacksonville Humane Society certainly enriched the lives of Zsa Zsa, Sadie and my family, and I am grateful that such compassionate organizations have long existed in Jacksonville and hopefully will do so long into the future.

I am also grateful that during my childhood, my friends and I were well served by many compassionate organizations and individuals—hospitals, pediatricians and animal shelters. Their efforts have made this part of the world a healthier place for us to grow up, and their examples provided us with role models of how we all should aspire to be.

Lifeguards and the Big "White Castle"

One of the most wonderful parts about growing up in Jacksonville was being so close to the Atlantic Ocean. I learned to love the sound of the waves and to love the clean smell of ocean breezes. I have marveled at beach sunrises, sunsets and the awesome storm fronts that pass overhead in the summer. I have enjoyed watching all the wildlife—the dolphins in the waves and the pelicans flying in formation. For me, it has always been a place of great beauty.

It can be no surprise that I have spent as many hours of my leisure time as I could find at the edge of our continent. Whether it was just getting my feet wet or cooling off in refreshing jade green water, I have enveloped myself in the wonders of the beach scenery for as many years as I have lived in Jacksonville.

Such beautiful scenery, however, can quickly become a nightmare landscape if someone nearby gets caught up in a rip current or gets hurt in the water. I remember with great clarity the dread that spread over me when my family and I went to Jacksonville Beach one summer day in the early '60s and witnessed a rescue.

Our beach blankets and towels had been spread near one of the lifeguard towers—the orange/red ones that resemble giant Adirondack chairs. We had our picnic ready and were preparing to eat when, rather

dramatically, the nearest lifeguard unfurled a large red flag and then dropped it to the sand. We noticed that down the beach several lifeguards were doing the same thing. From behind us, we heard the siren of a rescue truck hurrying past, down to where the last flag lay in the sand. Someone there was in trouble, and the lifeguard at that station had already run into the water to save him.

My family and I watched for some time, not feeling at all like eating our picnic lunch. Eventually, the truck came back toward us with a surfer who had been hit in the head with his board. The surfer was sitting up in the back of the truck, his head already bandaged. The truck then disappeared as it drove out of an access, to a hospital, we assumed. Only then did everything go back to normal. The flags were again hoisted to the backs of the lifeguard chairs, the lifeguards began their vigil yet again and we Ketchums felt safe and protected. It was amazing.

What we had witnessed was an efficient lifesaving system, the result of forward-thinking people from a century ago. According to a booklet published in 1986 called "Seventy-five Years of Service: American Red Cross Volunteer Life Saving Corps," Clarence H. McDonald came to Jacksonville in 1912 to be director of public recreation for the city of Jacksonville. He had come from Springfield, Massachusetts, where he had been a lifeguard and a Red Cross first-aid man at Lake Massosoit.

During McDonald's first week in town, a nurse drowned at Pablo Beach, now called Jacksonville Beach. He was horribly distressed about this senseless casualty and reported it and the fact that there were no lifeguards at Pablo Beach to W.E. Longfellow, the commodore at the national level of the United States Volunteer Life Saving Corps. Very quickly, Longfellow authorized McDonald to take a survey and then determined the need for a lifesaving corps at Pablo Beach.

These two men joined forces with Dr. Lyman G. Haskell, a man who had already trained his senior swimming and gymnastics classes in the techniques of the United States Volunteer Life Saving Corps. From these classes of 1912 came the first lifeguards of Station #1 at Pablo Beach. Before that time, the nearest facility providing first aid and medical treatment for visitors was in Jacksonville, over twenty-five miles away.

In the summer of 1914, the American Red Cross became associated with the group. As the sign on the building clearly says now, it became the American Red Cross Volunteer Life Saving Corps, providing lifeguards to protect Pablo Beach and all who would come to this area to enjoy the wonders of the Atlantic.

The wonderful "White Castle" that now stands at the very end of Beach Boulevard has been part of the beach scene longer than I have been alive, but before it was there, other structures served the guards and the community. The first structure was built in 1913 and was made of wood. It was forever suffering storm damage and was blown over twice, so in 1920, a station was built of concrete block. This served well for about twenty-five years, but time and the elements took a toll on the building. In 1945, after much discussion and consideration, the station was to be completely replaced since remodeling the old structure was no longer cost effective.

Unfortunately, the building had been demolished before they realized that they were unable to procure certain building materials because of conditions after the end of World War II. It wasn't until 1948 that the present building was officially completed and ready for use.

Southside resident Robert Sales, now eighty-three, knows all about being of service as a lifeguard. When he was about eighteen years old, he became part of the winter class of 1946's Lifeguard Corps. In the seventy-fifth anniversary booklet, he is quoted as saying, "We did not have much to look forward to. No station, one truck that would hardly run, and bathing suits that looked like they were full of bullet holes. We had an old Army hut that we were able to obtain from Camp Blanding. This was our station in 1946."

I got to interview Bob Sales in person in December 2011. He obviously was not eighteen anymore, but I could still make out the handsome young lifeguard recruit that he had been in the pictures that he showed me. He is clearly proud of his service as a lifeguard in the '40s. He is also proud to be a founder of the Life Guard Alumni Association.

Even though he spent many years as a caterer, a husband and a father raising a family, Sales obviously regards his time as a lifeguard as something very precious. His eyes lit up when he talked about it. During his tenure, he had two rescues and two assists to his credit. He remembered:

Robert Sales, winter class of 1946 Lifeguard Corps, with surfboard. *Courtesy of Robert Sales.*

This man was clinging to a piling of the old pier way out toward the end. And I was a bit shaky since this was my first rescue, and I didn't quite know what to expect. The man who was in trouble was quite distressed, but I did as I had been taught. I talked calmly to the guy to get him to calm down. I told him that I could not come near him until he settled down because he could drown us both. I then offered him the buoy that we lifeguards always took with us, and the man grabbed hold and I swam him toward the shore.

Today, lifeguards serve at the American Red Cross Volunteer Life Guard Station, and they man as many as twenty-three towers located up and down Jacksonville Beach. Don Connors, forty-one, a lieutenant in the present-day corps, said, "The volunteer lifeguards work on Sundays and

holidays. From Monday through Saturday, the City of Jacksonville Beach pays the guards."

He also told me that the corps has a tradition of naming the towers. Some are named for businesses, like the Mack Shack, a beer bar of the '40s that is now long gone. Other towers are named for deceased lifeguards of the corps. "Gabby Wilson" is the name of the tower named for Captain Gary "Gabby" Wilson. Another tower, the "Golden Greek," is named in honor of Captain George Patrinely. Robert Sales was recently honored by being the first honoree having one of the chairs named for him while he is still living.

When I asked Connors what it is about this job that attracts people to serve, he said, "It is different for each of us, but for me it is the ocean and wanting to do service. I really enjoy this, and many others who enjoy this job will go on to become EMTs or nurses or firemen. The job also makes you stay fit."

Connors also said that once a member has served eight years, he or she can retire and become a member for life. George E. Hapsis, seventy-eight, is one such "lifetime" lifeguard. He now spends the bulk of his free time volunteering and has been serving the corps for many years since his lifeguard days. Hapsis said that he grew up enjoying the beach and had a few scary moments of his own in the ocean: "One day, one of the lifeguards asked me how old I was. I said 'sixteen or seventeen,' and he said I was old enough to join the corps. I was so impressed that he thought enough to ask me that I went ahead and joined." Hapsis soon became part of the summer recruit class of 1950.

I must admit that the dashing image of a lifeguard at our beach still gives me a bit of a thrill. It isn't often that you can actually see real life heroes, those willing to risk life and limb in the service of humanity. There have been countless young lifeguards keeping the beaches safe throughout the century-long existence of the American Red Cross Life Saving Corps at Jacksonville Beach. They make the beach experience one of joy instead of one of tragedy and sorrow. And even though they haven't saved every soul in distress, just with the service of Robert Sales alone, four lives were saved and four families were spared much grief. These people certainly know what a difference his service has made.

American Red Cross Life Guard Station at Jacksonville Beach. *Courtesy of Jim Menge.*

Multiply that by the hundreds of men and women who have been part of the American Red Cross Life Saving Corps at Jacksonville Beach, and one can only begin to realize what a positive impact this service has had on the lives of us all.

Conclusion

After all is said and done, I think growing up in Jacksonville can be boiled down to just one word—constant. There are so many aspects to our city that have remained constant even as we have changed by growing older. I still feel the navy's presence as the P-3 Orions fly over my house each day, and my mind still wanders to those great people whose names are etched on the bridges I cross every day. We still nurture younger generations with school and church activities, even as we appreciate the beautiful Florida scenery that reminds us constantly of why we came here or why we stay.

Not long ago, I reread *The Yearling* by Marjorie Kinnan Rawlings, one of my all-time favorite authors. I was struck at the numerous scenes she depicted that reminded me of my growing up in Jacksonville. Rawlings wrote the following passage about Jody Baxter, the young north Florida boy of her story: "He went to bed in a fever and could not sleep. A mark was on him from the day's delight, so that all of his life when April was a thin green and the flavor of rain was on his tongue, an old wound would throb and a nostalgia would fill him for something he could not quite remember. A whip-poor-will called across the bright night, and suddenly he was asleep."

When I read this, I was immediately taken back to my childhood when, like Jody, my days were filled with delight—running through the woods

near my Jacksonville home all morning and riding bikes on Jacksonville streets all afternoon until the streetlights came on. And how many times had I marveled at the thin green of a Jacksonville April or felt the throb of nostalgia at the sound of the whippoorwill calling in the twilight outside my Southside home?

Jacksonville has grown and changed, but it has remained constant in the things that we value most—the devotion of its citizens toward its children and toward the beauty of its north Florida location. I am very happy that Jacksonville became my home, especially as I recall how sad I was when we first moved here—the thought of the old rotary phone in a vast and empty house back in East St. Louis, always in the back of my mind.

From this first and last uprooting, I have put down deeper roots in this better place, a constant place, where my friends and I flourished even as we skated at Skateland or fed peanuts to the elephants at the zoo or talked to our boyfriends and girlfriends on princess phones.

A different destiny might have had me writing another book about a different place, but I doubt it. I have the way and means to go anywhere else, but I have chosen to make Jacksonville my home forever. And that is all there is to it.

About the Author

After thirty-five years of teaching English in Jacksonville, Florida, Dorothy K. Fletcher began enjoying life as a writer. For almost four years, she wrote "By the Wayside," a nostalgia column for the *Florida Times-Union*. This culminated in her book *Remembering Jacksonville: By the Wayside*. She continues to freelance even as she travels with her husband, Hardy, plays with her grandchildren and tutors at her old elementary school.

Visit us at
www.historypress.net